# *Sweet* DRAWING

## LEARN TO DRAW
## MORE THAN 150 ADORABLE THINGS

OLGA ORTIZ

# CONTENTS

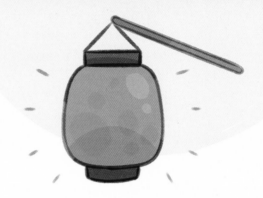

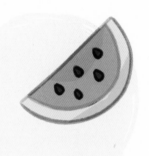

## Materials & Techniques

## Let's Draw!

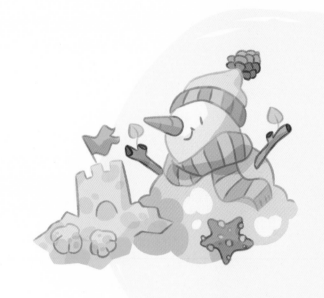

# INTRODUCTION

In this book, I want to share everything that I've learned in my years as an illustrator. Most of the time, I draw simple everyday objects, plants, animals, things from Japan... In short, if it's sweet, I draw it!

I love nothing more than to settle down with my sketchpad and a cup of tea and draw simple, sweet motifs: it's a great way to unwind.

My aim is to capture a little bit of that relaxed atmosphere in this book. Then, with a little bit of practice, you too will be able to draw the same sweet motifs in just a few steps.

You don't need any fancy tools and you don't even need to be particularly good at drawing—all you need is the desire to learn!

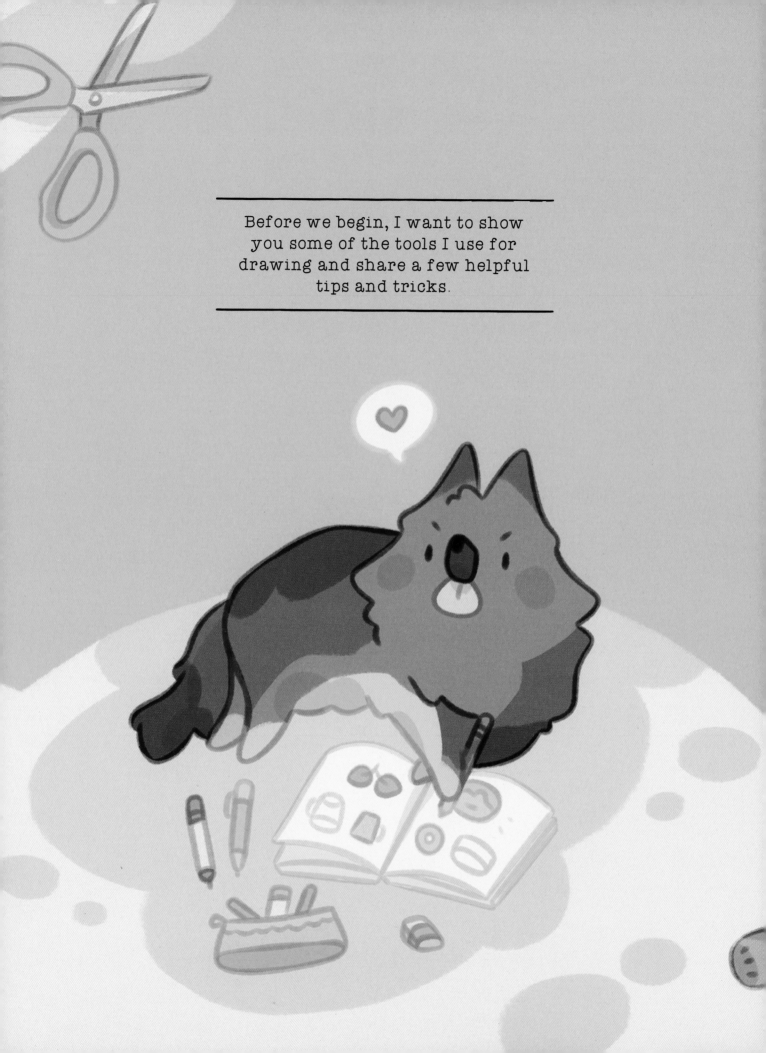

Before we begin, I want to show you some of the tools I use for drawing and share a few helpful tips and tricks.

# MATERIALS & TECHNIQUES

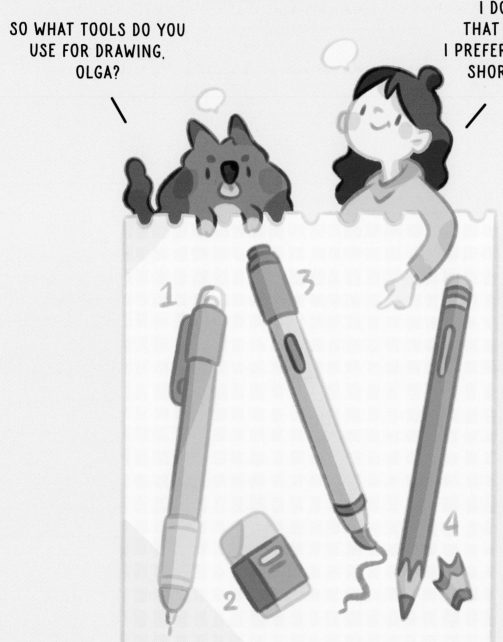

# TOOLS FOR DRAWING

Every artist has a preference for certain materials or brands. The perfect drawing tools are always the ones that you work with best. That's why this book includes useful suggestions to suit everyone. Just grab your favorite pencils and go!

When it comes to sketching, a 0.7mm mechanical pencil (1) is my preference. The things I draw are always really tiny, so the lines have to be very precise. I always use colored leads too, to stop the paper from getting smudged with graphite. My favorite colors are pink and orange.

I also have a dust-free eraser (2). It leaves no residue on the paper and my desk is a lot cleaner now as well. To color my drawings, I use alcohol markers (3). They dry more slowly than water-based markers.

With alcohol markers, I can finish a whole drawing without leaving behind any ugly lines along the edges of my coloring. As long as the ink is still wet, it can be colored over and the finished picture will look almost like a watercolor. One disadvantage of alcohol markers is that the ink is absorbed deeply into the ground. It bleeds through to the other side if you don't use specialist paper. But I don't worry about it too much. I add the final details with ordinary colored pencils (4). I use similar shades so the lines look softer.

# PAPER

My favorite sketchbook has soft, thin, light yellow paper. Against this background, the colors look warm and vibrant.

The only disadvantage is that I can only use one side of each sheet and need to place a piece of cardboard behind it so the ink doesn't bleed through onto the next page.

However, since the paper is so thin, it can't absorb that much ink, so the pens last a really long time.

I also have a second sketchbook for jotting down my ideas in pencil. I don't use any markers at this stage, so the paper in this sketchbook is slightly textured, which is especially good for sketching.

# SKETCHING

When you have an idea for a particular motif, get it down on paper first using very simple geometric shapes. Afterwards, you can focus on each individual component of the composition and add in the details.

TIP: WHEN SKETCHING, ONLY USE LIGHT PRESSURE. THAT WAY, THE LINES ARE EASIER TO ERASE. IF, AFTER REWORKING IT A FEW TIMES, PART OF YOUR DRAWING STARTS TO LOOK A BIT MESSY, COPY IT ONTO A NEW SHEET OF PAPER AND START OVER.

# SIMPLIFYING YOUR DRAWINGS

It's not always necessary to draw in perspective. Lots of the instructions in this book start with a front view.

TIP: ALL ARTISTS DRAW FROM REFERENCE WHEN NEEDED. DRAWING IS MUCH EASIER WHEN YOU HAVE SOMETHING TO GUIDE YOU.

Only once the composition is in place do I turn my attention to the perspective. With a bit of practice, you'll find it easier to draw in perspective right from the start.

# COLORING WITH MARKERS

If you've never worked with markers before, it's best to start with light colors. Don't draw your sketch in pencil. The lead is too dark, so the entire drawing can end up looking muddy. Use a colored pencil in pink or light blue instead.

You can then use markers to gradually build up the intensity of the color. So if you go over a colored area with the same color, the shade gets darker. You can create fantastic shadows this way. This is also why I recommend starting with light colors.

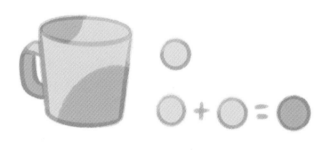

> **TIP:** WHEN YOU USE A DARK SHADE OF COLOR NEXT TO A LIGHT ONE, MAKE SURE THAT THE FIRST APPLICATION OF INK IS DRY. OTHERWISE THE INK WILL BLEED, CREATING UNWANTED BLENDING.

If your marker is running out of ink, you can fill an area gradually with circular motions. Take your time. That way, coloring becomes a meditation.

> **TIP:** I PREFER TO WORK WITH MUSTARD, PINK, LIGHT BLUE, PURPLE, LIGHT BROWN, AND OLIVE GREEN. ALL OF THESE COLORS HARMONIZE WELL WITH ONE ANOTHER.

Choosing which colors to use can be quite a challenge for beginners. It's best to choose just a handful for your first pictures, even if the result doesn't look very realistic. Pastel shades and light colors are ideal, particularly if they're warm. As well as for inspiration, you can also use my book to help you choose your color palette!

# IT'S ALL IN THE DETAILS

To add texture to the drawing, I add small circles to the motif in a darker color. This works especially well with fruit, fur, and bread.

When drawing glass or other shiny surfaces, the side of the object where the light falls should always be brighter. If you forget, you can add in the highlights afterwards in white pencil.

Sweet, simple patterns make a boring drawing come to life. Don't overdo it, though. Otherwise the picture can start to look "cluttered."

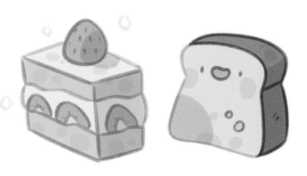

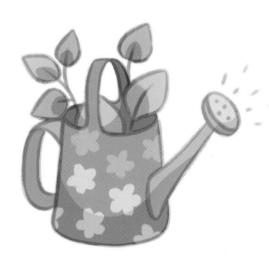

I rarely draw a background. My drawings are so simple, a background would be too much. Instead, I use clouds of color to highlight the ground underneath my motifs. I think it looks much better and doesn't overpower the drawing. A simple trick with a big impact!

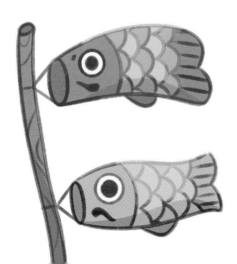

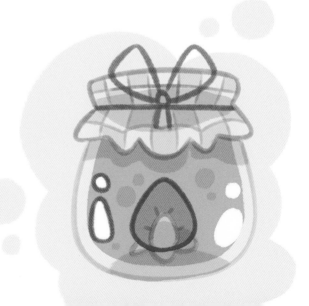

# SWEET DRAWING: A FEW TIPS

If you're now ready to try out some of
your own ideas, I can share a few
tricks with you to make your drawings
look even sweeter, whatever your
chosen motif.

## SHAPES

Use round shapes and round off each corner to
make the objects look soft and cute.

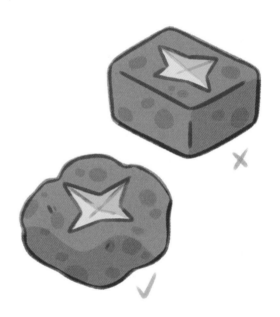

If you want to give something a chubby
appearance, just draw everything a little larger
than it actually is. I ignore "normal" proportions
too and draw baby animals with big heads and
tiny bodies. Large animals get big, soft bodies
and don't look as scary anymore.

## LESS IS MORE

You don't have to draw lots of details. Less is often more and then you can focus on the ones that matter. For example, instead of reproducing an animal's fur right down to the last detail, turn your attention to the silhouette. Is your animal's fur smooth or curly? Reflect this in the outline and it has the same effect. The result looks a lot sweeter too.

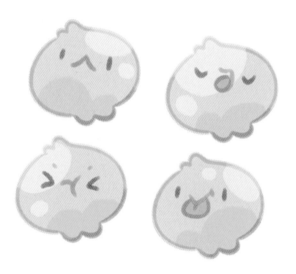

Simple, happy faces are always best. These can also be called "kawaii faces." You can use them anywhere: food, objects, and plants can all boast a cheerful smile.

## BEAUTIFUL CHAOS

Your creativity knows no bounds! I love drawing animals doing the things humans would do, for instance—that's always a lot of fun. I also like to draw things in places that you wouldn't expect. What do you think of this flowerpot made from a boot, for example?

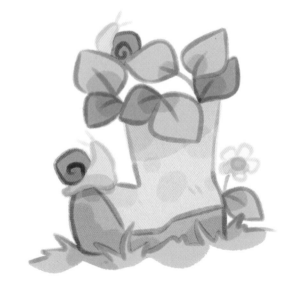

In this chapter, you'll find all sorts of sweet motifs to draw on nine different themes. And, of course, you can draw lots of different motifs together too, in any combination.

Each drawing is accompanied by easy-to-follow instructions showing you step-by-step how best to draw all of these sweet motifs. Add in little details as and how you like to make the pictures your own!

# LET'S
# DRAW!

WHAT WOULD YOU LIKE TO
DRAW FIRST? A KITTEN OR
A FLOWERPOT? PERHAPS
A BEAR FIGHTING A DRAGON?

# IN THE
## kitchen

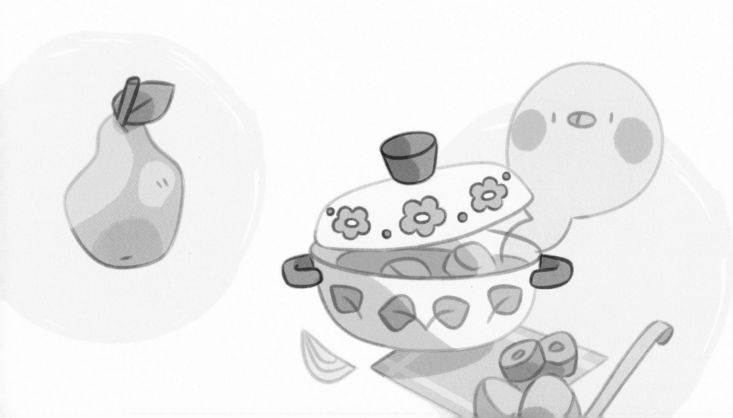

# CARROT

❶ START WITH AN OVAL. MAKE THE TOP WIDER THAN THE BOTTOM.

❸ DRAW THEM IN THE SHAPE OF CLOUDS ...

❷ THE LEAVES GROW OUT FROM THE TOP.

❹ ... OR AS LONG RECTANGLES WITH ROUNDED EDGES.

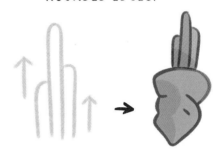

# CHOPPED CARROTS

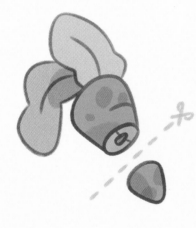

❶ TO COOK WITH YOUR CARROTS, YOU NEED TO CHOP THEM UP.

❷ THE SLICES CAN BE ROUND OR EVEN SQUARE.

# ONION

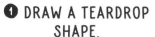

**1** DRAW A TEARDROP SHAPE.

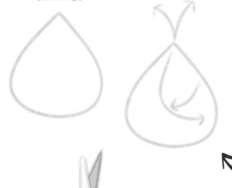

**2** THE LAYERS OF THE ONION RUN IN CURVED LINES FROM TOP TO BOTTOM.

**3** WHEN THE ONION IS CUT VERTICALLY, YOU CAN SEE THAT THE INSIDE LAYERS ARE SMALLER.

**4** I LIKE TO DRAW CUT SEGMENTS NEXT TO A WHOLE ONION.

# BOK CHOY

CURLY LEAVES ARE TOUGH TO DRAW; HOWEVER, IF YOU SIMPLIFY THE SHAPE, THEY LOOK LIKE VERTICAL CLOUDS.

**1** THE BASIC SHAPE IS AN OVAL WITH A SEMICIRCLE ADDED TO IT.

**2** TO FINISH, DRAW A FEW LEAVES STICKING OUT FROM THE SIDES.

# CABBAGE

**1** START WITH A CIRCLE.

**2** DIVIDE THE CIRCLE WITH CURVED LINES RUNNING FROM TOP TO BOTTOM FOR THE LEAVES.

**3** THE LAST FEW LEAVES CAN BE DRAWN STICKING OUT CASUALLY FROM THE SIDES.

# TURNIP

**2** ADD ROUND, CLOUD-SHAPED LEAVES ON TOP.

**1** FIRST DRAW AN OVAL-SHAPED CIRCLE.

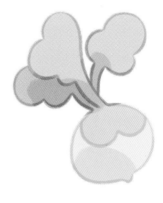

**3** MAKE SURE THE LEAVES HAVE LONG STALKS.

# SPRING ONION

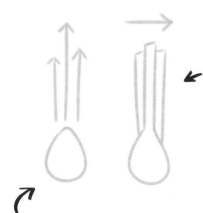

**2** DRAW THE LEAVES AS VERY LONG RECTANGLES CUT STRAIGHT ACROSS THE TOP.

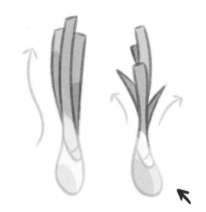

**1** START WITH A TEAR-DROP SHAPE.

**4** WHEN THE LEAVES ARE CUT, THEY LOOK LIKE LITTLE RINGS WITH AN IRREGULAR CIRCULAR SHAPE.

**3** SOME OF THE LEAVES CAN STICK OUT TO THE LEFT AND RIGHT.

# SALT & PEPPER

SALT AND PEPPER SHAKERS FOR THE DINNER TABLE LOOK EXTRA SWEET WHEN DRAWN AS LITTLE MUSHROOMS.

**1** DRAW A SEMICIRCLE ON TOP OF A RECTANGLE.

**2** CHANGE THE SIZE RATIO OF THE TWO BASIC SHAPES TO CREATE YOUR OWN UNIQUE MUSHROOM.

**3** DON'T FORGET THE LITTLE HOLES ON THE CAP; OTHERWISE YOUR SALT AND PEPPER SHAKERS WON'T WORK!

# CHOPPING BOARD

**1** DRAW A SIMPLE RECTANGULAR BOARD WITH A LONG HANDLE.

**2** REMEMBER TO ADD THE IRREGULAR CIRCLES FOR THE GRAIN. THAT WAY, YOU CAN SEE THAT THE CHOPPING BOARD IS MADE OUT OF WOOD.

# LADLE

**1** YOU NEED A SEMI-CIRCLE WITH A LONG HANDLE ENDING IN A CURVE.

**2** ADD A SEMICIRCLE TO SHOW THE LADLE IS FULL OF STEW.

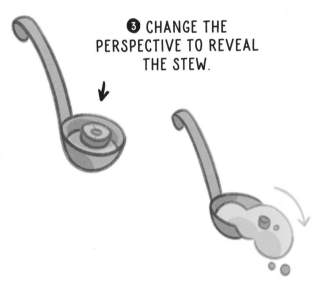

**3** CHANGE THE PERSPECTIVE TO REVEAL THE STEW.

**4** WHEN THE STEW SPILLS OVER THE EDGE, MY MOUTH STARTS WATERING!

# CASSEROLE

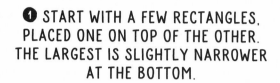

**1** START WITH A FEW RECTANGLES, PLACED ONE ON TOP OF THE OTHER. THE LARGEST IS SLIGHTLY NARROWER AT THE BOTTOM.

**2** ADD A HANDLE ON EACH SIDE AND DECORATE THE POT.

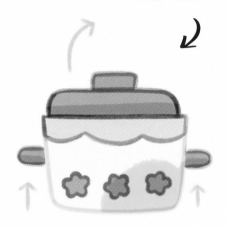

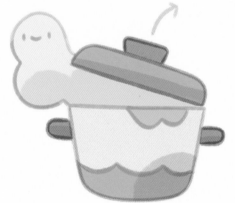

**3** OPEN THE LID A LITTLE TO ALLOW A THICK CLOUD OF STEAM TO ESCAPE. YOUR DRAWING WILL LOOK MORE REALISTIC—AND A LOT SWEETER TOO.

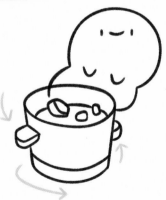

**4** IF YOU WANT TO LOOK INSIDE THE POT, REPLACE THE RECTANGLE WITH A CYLINDER AND TURN THE HANDLE 45°.

**5** YOU CAN DRAW A SWEET LONG-HANDLED POT WITH THESE STEPS TOO. YOU DON'T NEED A LID—JUST ADD A LONG HANDLE.

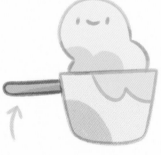

# CHEESE

**❶** DRAW A LARGE TRIANGLE
SHAPED LIKE A SLICE OF CAKE.

**❷** ADD LOTS OF CIRCLES,
VARIOUS SIZES.

**❸** HOLLOW OUT THE CIRCLES
AT THE SIDES.

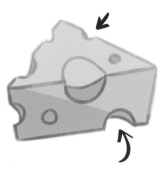

**❹** SHADE THE CIRCLES INSIDE THE
CHEESE USING A DARKER COLOR
SO THEY LOOK LIKE HOLES.

# EMPANADA

**❷** BEFORE COOKING, THE EDGES OF THE
PASTRY CASES ARE SEALED TOGETHER
WITH A FORK. YOU CAN SHOW
THE IMPRINTS OF THE FORK
WITH SMALL LINES.

**❶** DRAW A SEMICIRCLE.
REPLACE THE OUTER EDGE
WITH A WAVY LINE.

**❸** GIVE THE EMPANADA
A LITTLE FACE.
SWEET, HUH?

# APPLE

**3** THE SHAPE IS THE SAME WHEN DRAWING HALF AN APPLE. JUST DON'T FORGET THE CORE!

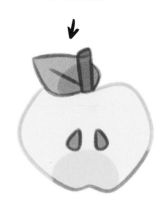

**1** THE BASIC SHAPE OF AN APPLE IS A CIRCLE WITH A SMALL HOLLOW IN THE TOP AND BOTTOM.

**2** ADD THE STEM AND A LEAF—IT'LL LOOK GOOD ENOUGH TO EAT!

# PEAR

**2** FOR ALL THE OTHER DETAILS, FOLLOW THE SAME STEPS AS FOR THE APPLE.

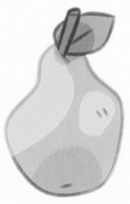

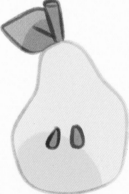

**1** DRAW TWO CIRCLES ONE ON TOP OF THE OTHER, WITH A HOLLOW IN EACH.

# BANANA

A BANANA LOOKS LIKE A CHEERFUL, SMILEY MOUTH WITH STRAIGHT LINES AT THE CORNERS.

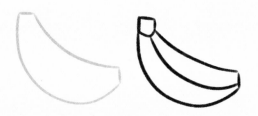

**❷** TO SWITCH THINGS UP A BIT, YOU CAN MAKE THE BANANA A LITTLE MORE ANGULAR.

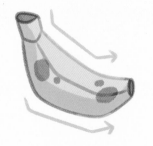

**❶** ADD A SQUARE STEM AT ONE END AND DRAW A LINE THROUGH THE MIDDLE, FOLLOWING THE CURVE OF THE OUTLINE.

**❸** TO PEEL THE BANANA, DRAW FOUR CURVED TRIANGLES ON EACH SIDE. GOOD ENOUGH TO EAT!

# LEMON

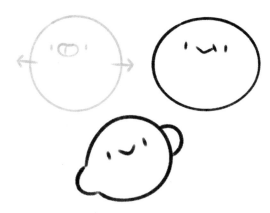

**❷** FOR COLORING, I USED TWO DIFFERENT SHADES OF YELLOW TO GIVE THE FRUIT SOME TEXTURE.

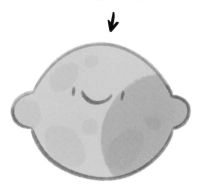

**❶** DRAW AN OVAL WITH A LITTLE EAR ON EACH SIDE AND THAT'S IT—YOU HAVE A LEMON!

# STRAWBERRY

❶ START WITH A WIDE UPSIDE-DOWN TEARDROP SHAPE.

❸ ADD FOUR OR FIVE SMALL LEAVES TO THE TOP AND YOU'RE DONE!

❷ PLACE SOME SMALL TEARDROPS INSIDE THE SHAPE.

❹ THE INSIDE OF THE STRAWBERRY IS LIGHTER. DRAWN UPSIDE DOWN, IT DOESN'T FALL OVER.

# BLUEBERRY

❶ START WITH A CIRCLE AND DRAW A SMALL FLOWER INSIDE.

❷ IF YOU WANT TO SHOW THE BERRY FROM THE OTHER SIDE, SIMPLY ADD A SMALL DOT. THE FLOWER ON THE OTHER SIDE IS BARELY VISIBLE.

❸ I USUALLY DRAW SEVERAL BERRIES BECAUSE THEY'RE SO SMALL. ADD A FEW LEAVES TO MAKE THE DRAWING LOOK MORE BALANCED.

# RASPBERRY

❸ ADD A FEW SMALL LEAVES AND THE STEM.

❶ START WITH THREE SMALL CIRCLES.

❷ ADD SOME MORE CIRCLES AROUND THE ONES YOU'VE ALREADY DRAWN UNTIL YOU HAVE THIRTEEN IN TOTAL.

# HONEYDEW MELON & WATERMELON

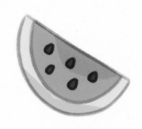

❶ DRAW A SEMICIRCLE AND ADD A SECOND INSIDE THIS FOR THE SKIN.

❷ FOR THE WATERMELON, ADD A FEW TEARDROP-SHAPED SEEDS.

❸ FOR THE HONEYDEW MELON, ADD THE SEEDS, AS WELL AS A SMALL SEMICIRCLE FOR THE CORE.

IF YOU WANT TO DRAW A TRIANGULAR PIECE OF MELON, START WITH A PIZZA-SLICE SHAPE. FOR HONEYDEW MELON, DON'T FORGET TO REMOVE THE TOP.

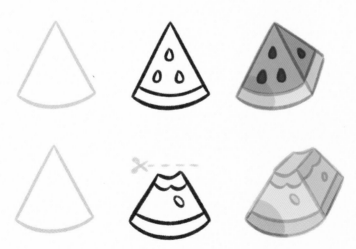

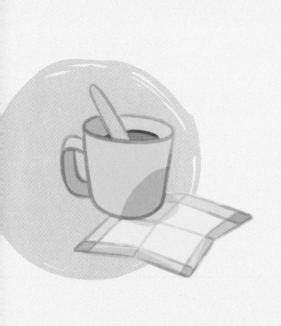
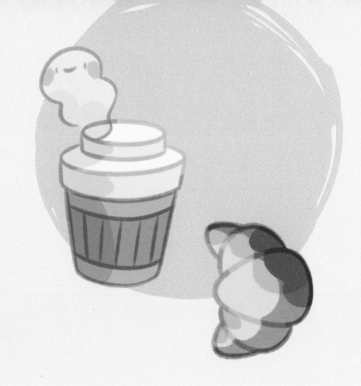

# IN THE
## Bakery

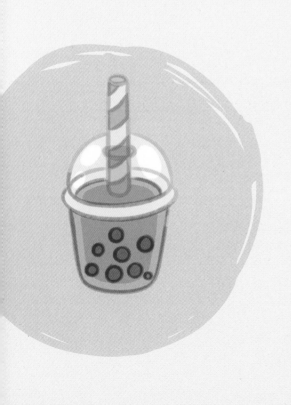
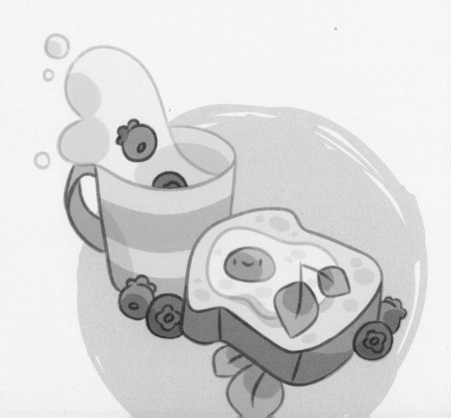

# PRETZEL

NOW THINGS GET A LITTLE MORE COMPLICATED.

❶ DRAW AN ARCH, MAKING SURE THAT THE ENDS CROSS OVER ONE ANOTHER.

❷ MAKE SURE THAT THE ARCH LOOKS THREE-DIMENSIONAL AND THE PRETZEL LOOKS ROUND.

❸ DRAW ONE END OF THE PRETZEL ON TOP AND THE OTHER UNDERNEATH.

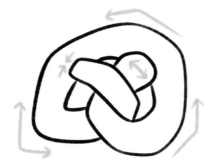

❺ NOW THE ONLY THING MISSING IS THE SALT. PERFECT!

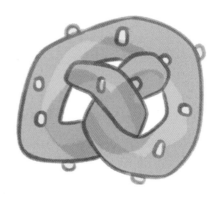

❹ WITH A LITTLE PRACTICE, YOU CAN DRAW YOUR PRETZELS A LITTLE LESS ROUND. THEN THEY'LL LOOK MORE REALISTIC.

# SLICE OF BREAD

**1** START WITH A TRAPEZOID AND ADD A BIT MORE VOLUME TO THE TOP.

**2** IT'LL LOOK EVEN MORE REALISTIC IF YOU ADD A SLIGHT CURVE TO THE BOTTOM.

**3** FOLLOW THE SAME STEPS AND DRAW THE SLICE OF BREAD A LITTLE THICKER TO CREATE A SLICE OF TOAST—OR EVEN A WHOLE LOAF OF BREAD!

# TOAST

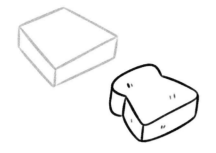

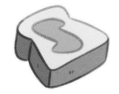

**2** SHOW THE JAM WITH AN S SHAPE.

**1** DRAW A THREE-DIMENSIONAL TRAPEZOID TO BRING SOME DELICIOUS TOAST TO THE TABLE.

**3** ADD A SMALL CUBE AND YOU HAVE A SLICE OF TOAST WITH BUTTER.

# FRIED EGG

**2** MAKE THE EDGES MORE CURVED AND PLACE THE YOLK SLIGHTLY OFF-CENTER. MMM, DELICIOUS!

**1** START A SIMPLE FRIED EGG BY DRAWING A SMALL CIRCLE INSIDE OF A LARGER ONE.

# TOAST WITH FRIED EGG

**1** PLACE A SLICE OF CHEESE ON THE TOAST. THE CORNERS OF THE CHEESE POINT DOWNWARD SO IT LOOKS AS IF THE CHEESE HAS MELTED.

**2** THEN ADD THE FRIED EGG ON TOP. FINALLY, THIS DELICIOUS SNACK IS GARNISHED WITH A FEW BASIL LEAVES..

# BUBBLE TEA

**1** AT FIRST GLANCE, THIS LOOKS A LITTLE MORE COMPLICATED. FIRST DRAW A CYLINDER AND MAKE IT SLIGHTLY NARROWER AT THE BOTTOM. PLACE A SEMICIRCLE ON TOP FOR THE LID. THE CONTAINER IS TRANSPARENT, SO DON'T RUB OUT ANY OF THE LINES.

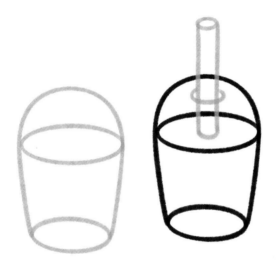

**2** MAKE A HOLE BY ADDING A SMALL CIRCLE IN THE TOP CENTER OF THE LID. DRAW A LONG, NARROW CYLINDER INSIDE THIS CIRCLE FOR THE STRAW.

**3** IF YOU'RE UP FOR THE CHALLENGE, YOU CAN ADD A RIM TO THE LID AS WELL. MAKE SURE YOU CAN SEE IT AT THE BACK OF THE CUP TOO. FINALLY, ADD SOME TAPIOCA PEARLS INSIDE AND SOME DETAIL TO THE STRAW.

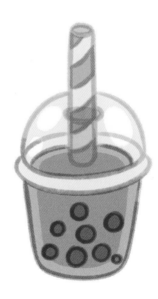

# COFFEE TO GO

**❶** FOR THE COFFEE CUP, FOLLOW THE SAME STEPS AS FOR BUBBLE TEA.

**❸** DON'T FORGET THE PAPER SLEEVE, AND ADD A CUTE LITTLE CLOUD OF STEAM TOO.

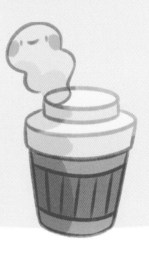

**❷** THIS TIME, THOUGH, THE CUP IS NOT TRANSPARENT AND THE LID IS FLAT.

# LEMONADE

**❷** THEN ADD A LID ON TOP. FILL THE BOTTLE WITH MINERAL WATER AND YOUR CHOICE OF FRUIT PIECES. STRAWBERRY LEMONADE IS MY FAVORITE!

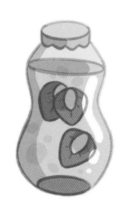

**❶** FIRST, DRAW TWO CIRCLES AND JOIN THEM TOGETHER WITH TWO CURVED LINES.

# FRUIT JELLY

**❶** DRAW A CIRCLE AND ADD A LID ON TOP.

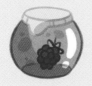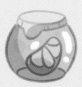

**❷** DRAW A PIECE OF FRUIT OR SMALL FRUITS SUCH AS RASPBERRIES OR BLUEBERRIES INSIDE THE JAR.

# TEAPOT

❶ START WITH A CIRCLE AND MAKE IT FLAT ON THE TOP AND BOTTOM. ON ONE SIDE OF THE CIRCLE, DRAW THE HANDLE FROM TOP TO BOTTOM WITH A CURVED LINE.

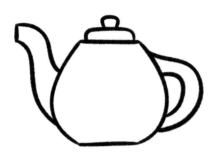

❷ ON THE OTHER SIDE, ADD THE SPOUT BY DRAWING AN S LINE, STARTING FROM THE BOTTOM. BOTH THE HANDLE AND THE SPOUT ARE WIDER AT THE BOTTOM THAN AT THE TOP.

❸ GIVE YOUR TEAPOT A LID AND ADD IN ANY DETAILS. A FLORAL OR WAVY PATTERN ALONG THE EDGES ALWAYS LOOKS GOOD.

# TEABAG

❶ DRAW A SMALL RECTANGLE WITH A FLAP ALONG THE TOP EDGE.

❷ NOW YOU JUST NEED TO ADD SOME PERSPECTIVE. DRAW THE SIDE AS A NARROW TRIANGLE.

❸ DON'T FORGET THE STRING WITH THE TEABAG LABEL!

# MUG

**1** A MUG IS A CYLINDER WHICH IS NARROWER AT THE BOTTOM THAN AT THE TOP.

**3** NOW YOU CAN FILL THE MUG WITH THE DRINK OF YOUR CHOICE.

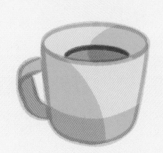

**2** DRAW A WIDE HANDLE AND YOU'RE DONE!

# NAPKIN

A NAPKIN IS NOTHING MORE THAN A SIMPLE SQUARE—ADD IN A FEW FOLDS TO MAKE IT MORE INTERESTING.

**1** NAPKINS ARE USUALLY FOLDED ONCE LENGTHWISE AND ONCE WIDTHWISE.

**2** AT THE CENTER OF EACH EDGE, THE NAPKIN HAS CREASES FACING UPWARD OR DOWNWARD DEPENDING ON HOW IT IS FOLDED.

# CROISSANT

HAVE YOU EVER SEEN HOW A CROISSANT IS MADE? THE DOUGH IS ROLLED OUT INTO A TRIANGLE, WHICH IS THEN ROLLED UP FROM THE BASE TO THE TIP. THAT'S WHY CROISSANTS ARE THICK IN THE MIDDLE AND THINNER AT THE SIDES.

❶ TO MAKE THE BASIC SHAPE, FIRST DRAW A TRIANGLE. THIS FORMS THE CENTER OF THE CROISSANT. THEN DRAW A RECTANGLE ON THE LEFT AND RIGHT. ADD TRIANGLES TO THE ENDS TO GIVE THE CROISSANT ITS CORNERS.

❷ GRADUALLY ADD SOME VOLUME TO THE LINES TO GIVE THE CROISSANT A THREE-DIMENSIONAL APPEARANCE.

❸ YOU CAN DRAW CROISSANTS IN A C SHAPE TOO, WITH THE ENDS ALMOST TOUCHING.

# DOUGHNUT

DRAWING A DOUGHNUT IS EASY, HOWEVER THE PERFECT DOUGHNUT
LOOKS CHUNKY AND ROUND.

**1** ROUND OFF A RECTANGLE AS
MUCH AS YOU CAN.

**2** ADD A HOLE IN THE CENTER
AND THE THICK EDGE.

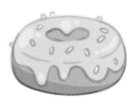

**3** LET THE ICING RUN
DOWN THE SIDES, ADDING
A FEW THICK DROPS HERE
AND THERE, AS WELL AS IN
THE MIDDLE.

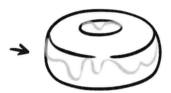

**4** FINALLY, DECORATE
THE DOUGHNUT WITH
LOTS OF COLORFUL
SPRINKLES.

# CINNAMON ROLL

FIRST AN EXERCISE: DRAW A SPIRAL,
STARTING FROM THE MIDDLE AND ENDING AT THE BOTTOM.

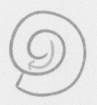

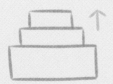

**1** FROM THE SIDE, THE CINNAMON
ROLL LOOKS LIKE A TALL,
THREE-TIER CAKE.

**2** NOW THINGS GET A BIT MORE
CHALLENGING: THIS TIME, DRAW
A COLLAPSED SPIRAL.

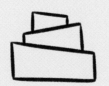

**3** GIVE THE SPIRAL
SOME VOLUME.

**4** ADD A DOLLOP
OF ICING,
DRIPPING DOWN
ONTO THE TABLE.

# PANCAKES

❶ FIRST, DRAW TWO CIRCLES, ONE ON TOP OF THE OTHER. OUR PANCAKES SHOULD BE REALLY THICK AND ROUND.

❷ WHEN IT COMES TO TOPPINGS, THE CHOICE IS YOURS: MELTED BUTTER, STRAWBERRIES, BLUEBERRIES, AND PLENTY OF HONEY OR SYRUP.

SINCE PANCAKES ARE SO EASY TO DRAW, WHY NOT GIVE THEM CUTE LITTLE FACES?

❶ TWO SMALL CIRCLES ON TOP OF THE FIRST AND THE PANCAKE HAS TEDDY BEAR EARS.

❷ ADD TWO TRIANGLES AND THE PANCAKE LOOKS LIKE A CAT FACE.

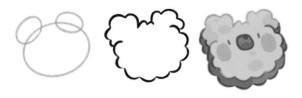

❸ IF YOU DRAW A WAVY OUTLINE INSTEAD OF A STRAIGHT ONE, THE PANCAKE LOOKS LIKE A SWEET LITTLE DOG.

# SLICE OF CAKE

❶ THIS SLICE OF CAKE HAS THREE LAYERS, SO THE TRIANGLE NEEDS TO BE REALLY THICK TO MAKE ROOM FOR THEM ALL.

❷ IN THE MIDDLE LAYER, USE SEMICIRCLES TO MAKE HALVED STRAWBERRIES.

❸ DECORATE THE TOP LAYER WITH A DOLLOP OF WHIPPED CREAM OR A STRAWBERRY.

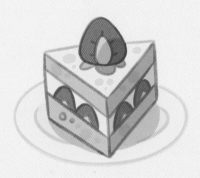

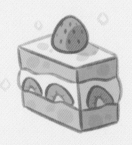

❹ THE SLICE CAN ALSO BE RECTANGULAR. TO MAKE EACH INDIVIDUAL LAYER LOOK THICK AND MOIST, THE TRANSITIONS BETWEEN THEM SHOULD BE SOFT AND UNEVEN.

❺ SERVE THE SLICE ON A PLATE OR A NAPKIN TO MAKE IT LOOK EVEN MORE APPETIZING.

# STRAWBERRY JAM

❶ FIRST, DRAW A CIRCLE AND EXTEND THE SIDES UPWARD A LITTLE. COMPLETE THE SHAPE WITH TWO STRAIGHT VERTICAL LINES AT THE TOP AND FLATTEN OUT THE BOTTOM.

❷ IF YOU WANT TO DRAW AN OPEN JAM JAR, YOU NEED TO ADD A THREAD AT THE TOP FOR THE SCREW LID. LEAVE SOME SPACE BETWEEN THE EDGE OF THE JAR AND THE FILLING TO GIVE THE APPEARANCE OF THICK GLASS.

❸ A CLOSED JAR NEEDS A LID. THE JAR IS FILLED WITH JAM AND A FEW PIECES OF FRUIT. DON'T FORGET THAT A GLASS SURFACE ALWAYS NEEDS A FEW HIGHLIGHTS.

❹ WANT TO GIVE THE JAR AS A GIFT? THEN COVER THE LID WITH A SMALL PIECE OF CLOTH, FASTENED WITH A RIBBON.

# SHORTBREAD

**❸** NOW DRAW TWO SMALLER CIRCLES ALONG THE TOP AND BOTTOM EDGES AND THREE ALONG EACH SIDE.

**❶** DRAW A RECTANGLE FOR THE BASIC SHORT-BREAD SHAPE.

**❷** DRAW A SMALL CIRCLE IN EACH CORNER. THE CORNER IS IN THE CENTER OF THE CIRCLE.

**❹** ERASE ALL OF THE LINES EXCEPT FOR THE OUTLINE AND SHOW THE HOLES IN THE TOP OF THE SHORT-BREAD WITH SMALL CIRCLES.

# CHOCOLATE CHIP COOKIE

**❷** THIS SORT OF COOKIE ALWAYS HAS A VERY IRREGULAR SHAPE.

**❶** THE BASIC SHAPE IS A CIRCLE.

**❸** SPRINKLE A FEW CHOCOLATE CHIPS ON TOP.

# SANDWICH COOKIE

**❷** DIVIDE THE CUBOID INTO THREE LAYERS. IT'S IMPORTANT THAT THE FILLING IS GOOD AND THICK.

**❶** DRAW A CUBOID.

**❸** ROUND OFF THE EDGES OF THE CREAM SLIGHTLY SO IT LOOKS AS IF IT'S OOZING OUT FROM BETWEEN THE TWO COOKIES.

# FLAN & JELLY

❶ THE SAME BASIC SHAPE, A CONICAL CYLINDER, CAN BE USED TO DRAW EITHER A FLAN OR JELLY.

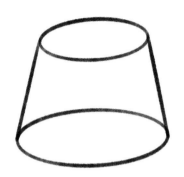

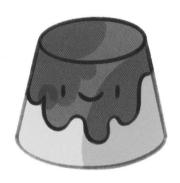

❷ IF YOU POUR CARAMEL SAUCE OVER THE TOP UNTIL IT DRIPS DOWN THE SIDES, YOU'VE MADE A FLAN.

❸ FOR A DELICIOUS JELLY, FIRST DRAW SMALL SEMICIRCLES AROUND THE TOP EDGE OF THE SHAPE. THEN DRAW LINES FROM BETWEEN EACH SEMICIRCLE DOWN TO THE BOTTOM EDGE OF THE SHAPE. THE SEGMENTS ARE THEN CONNECTED WITH SMALL ARCHES ALONG THE BOTTOM.

# MARSHMALLOWS

**1** MARSHMALLOWS ARE SMALL, ROUND CYLINDERS.

**3** STICK A COUPLE ONTO A WOODEN SKEWER ONE ON TOP OF THE OTHER AND THAT'S IT. YOUR SUPER-SWEET SNACK IS READY.

**2** MAKE SURE THAT THE LINES AT THE SIDES ARE CURVED.

# MACARON

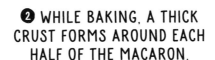

**2** WHILE BAKING, A THICK CRUST FORMS AROUND EACH HALF OF THE MACARON.

**1** DRAW THREE RECTANGLES WITH ROUNDED EDGES, ONE ON TOP OF THE OTHER. THE THINNER RECTANGLE IN THE MIDDLE IS THE FILLING.

**3** GIVE THIS CRUST AN UNEVEN SHAPE. THIS WILL STOP THIS SUPER-TASTY TREAT FROM LOOKING LIKE AN ORDINARY COOKIE.

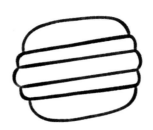

# MUFFINS

- - - - -

MUFFINS COME IN LOTS OF DIFFERENT SHAPES AND SIZES
AND A VARIETY OF PAPER CASES.

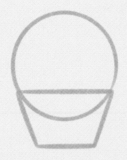

**❶** STILL, THEY ALL HAVE
THE SAME BASIC SHAPE:
A CIRCLE AND A TRAPEZOID.

**❷** BECAUSE MUFFINS ARE BAKED
IN THE OVEN, THE CIRCLE NEEDS TO PROJECT
OVER THE EDGES OF THE RECTANGLE.

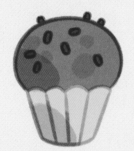

**❸** NOW GIVE THE PAPER CASE A WAVY EDGE
AND DECORATE THE FINISHED MUFFIN
WITH CHOCOLATE SPRINKLES.

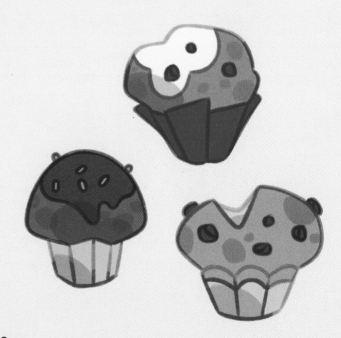

**❹** YOU CAN MAKE THE MUFFIN
WHATEVER SHAPE YOU WANT. AS YOU
CAN SEE, THERE ARE LOTS OF DIFFERENT
WAYS OF DRAWING THEM.

# LOAF OF BREAD

**❶ DRAW A CUBOID WITH ROUNDED EDGES.**

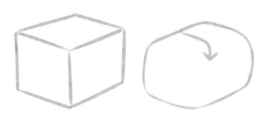

**❷ THIS LOAF HAS AN INCISION IN THE MIDDLE TO HELP THE CRUST EXPAND.**

**❸ THE CUT IS V-SHAPED AND SLIGHTLY LIGHTER THAN THE CRUST.**

**❹ NOW SPRINKLE THE BREAD WITH A FEW PIECES OF GRAIN.**

# FARMHOUSE LOAF

THE STEPS ARE THE SAME AS FOR THE LOAF OF BREAD. IN THIS CASE, THOUGH, THE CUT IS LARGER AND IN THE SHAPE OF AN X.

# SANDWICH

**❶ NOW CUT THE BREAD LENGTHWISE AND GIVE IT A DELICIOUS FILLING.**

**❸ THE FLAG IS THE ICING ON THE CAKE!**

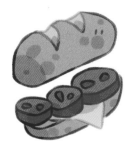

**❷ HOW ABOUT CHEESE AND FRESH TOMATO?**

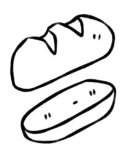
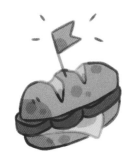

# SWEET THINGS FROM
## Japan

# MOCHI

- - - -

MOCHI ARE SMALL CAKES MADE FROM GLUTINOUS RICE. THEY'RE
REALLY VERY STICKY, SO INSTEAD OF BEING EATEN BY HAND,
THEY'RE USUALLY THREADED ONTO SKEWERS.

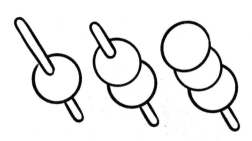

**2** YOU CAN SHADE ALL OF THEM A CREAM COLOR.
HOWEVER, IF YOU USE A COMBINATION OF PINK,
CREAM, AND GREEN, THEY'LL BE EASIER
TO TELL APART.

**3** THEY LOOK EXTRA SWEET
WITH A CAT FACE!

**1** DRAW THREE CIRCLES ONE
ON TOP OF THE OTHER.

# TAKOYAKI

- - - - - -

TAKOYAKI IS MY ALL-TIME FAVORITE JAPANESE DISH! TAKOYAKI
ARE SMALL DUMPLINGS FILLED WITH OCTOPUS AND SERVED
WITH MAYONNAISE AND DRIED BONITO FLAKES.

**3** THE SAUCE RUNS
DOWN THE SIDES OF
THE TAKOYAKI.

**5** I CAN'T GET ENOUGH OF
THEM, SO BE MY GUEST AND
DRAW THREE OR FOUR!

**1** FIRST DRAW A CIRCLE.

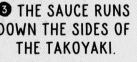

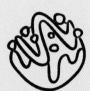

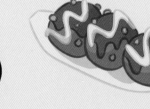

**4** GARNISH THEM,
PERHAPS WITH A SCATTERING
OF SPRING ONIONS.

**2** DECORATE IT WITH MAYONNAISE
IN AN S SHAPE.

49

# ONIGIRI

❶ START WITH A TRIANGLE, ROUNDED ALONG ALL SIDES.

❷ THE RICE CAN BE STICKY, SO PLACE A STRIP OF SEAWEED UNDERNEATH IT.

❸ TO SHOW THAT THE ONIGIRI IS MADE OUT OF RICE, YOU CAN GIVE IT UNEVEN EDGES AND ADD A FEW INDIVIDUAL GRAINS OF RICE.

❹ SOME ONIGIRI ARE FILLED WITH UMEBOSHI (A JAPANESE PLUM).

❺ FROM THE SIDE, THE ONIGIRI SHOULD LOOK AS ROUND AS POSSIBLE.

# NIGIRI

❶ FOLLOW THE SAME STEPS AS FOR THE ONIGIRI. INSTEAD OF A TRIANGLE, THOUGH, START WITH A RECTANGLE.

❷ DON'T FORGET THE GRAINS OF RICE!

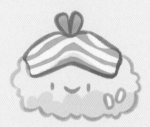

❸ ADD A RECTANGLE WITH A TAIL AS A TOPPING.

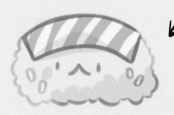

❹ TO TOP WITH SALMON OR TUNA, DRAW A SIMPLE RECTANGLE INSTEAD.

❺ THE COLORS SHOULD BE AS REALISTIC AS POSSIBLE.

# URAMAKI

– – – – –

URAMAKI ARE SMALL ROLLS OF RICE WITH A FILLING IN THE MIDDLE.

❶ DRAW A ROUNDED SQUARE WITH A SPIRAL IN THE MIDDLE.

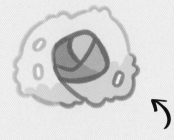

❷ DIVIDE THE INSIDE INTO THREE SECTIONS AND SHADE THEM DIFFERENT COLORS. I ALWAYS USE WARM SHADES TO IMITATE RAW FISH.

# NORIMAKI

– – – – –

❷ DECORATE THE TOP LIKE THE URAMAKI VIEWED FROM THE FRONT AND ADD A FEW GRAINS OF RICE.

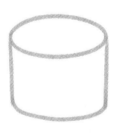

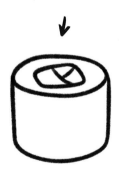

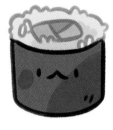

❶ START WITH A CYLINDER.

❸ NOW WRAP THE CYLINDER IN A SHEET OF DARK-GREEN SEAWEED AND DRAW A SWEET FACE ON IT.

# TEMPURA

TEMPURA IS FOOD FRIED IN BATTER. THERE CAN BE ANYTHING AT ALL WRAPPED INSIDE THE BATTER COATING. THE CONTENTS—IN THIS CASE, A SHRIMP—CAN BE SUGGESTED BY THE SHAPE.

**2** THE OUTLINE IS UNEVEN.

**1** DRAW A ROUND BODY AND MAKE A TAIL FROM TWO CIRCLES.

**3** HIGHLIGHTS SHOW THAT THIS TREAT IS ESPECIALLY FATTY!

# STEAMED BUN

**2** THIS SMALL BUN HAS A MEAT FILLING. SCATTER WITH A LITTLE SPRING ONION AND IT'S DONE!

**1** DRAW AN OVAL AND MAKE THE TOP EDGE, WHERE THE BUN HAS BEEN CLOSED AFTER FILLING, SLIGHTLY UNEVEN.

# RAMEN

- - - -

THIS JAPANESE NOODLE SOUP CAN HAVE A LOT OF DIFFERENT INGREDIENTS.
MY "RECIPE" IS SIMPLE YET WONDERFULLY VIBRANT.

❶ WHETHER DRAWN INDIVIDUALLY
OR TOGETHER, RAMEN NOODLES ARE
ALWAYS VERY WAVY.

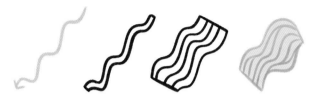

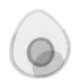

❷ FOR THE EGG, DRAW AN OVAL WITH
A SUBTLE TEARDROP SHAPE AND PLACE A
SMALL CIRCLE IN THE MIDDLE.

❸ THE SEAWEED IS CUT
UP AND DRAWN AS
RECTANGLES.

❹ YOU CAN ADD IN A FEW STRIPS OF
MEAT TOO. FOR SIMPLICITY'S SAKE,
YOU CAN DRAW THEM LIKE
RASHERS OF BACON.

❺ FINALLY DRAW
THE BIG BOWL, WHICH
HAS A SMALL BASE.

❻ ADD ALL OF THE INGREDIENTS, THE
CHOPSTICKS, AND A THICK CLOUD OF STEAM
WITH A FRIENDLY, SMILEY FACE.

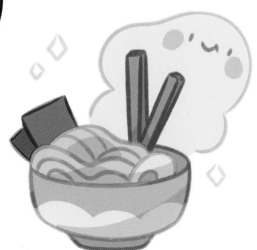

# ICE CREAM SUNDAE

**❷** ADD A BIG SCOOP OF ICE CREAM. IT'S BEGINNING TO MELT ALREADY AND IS RUNNING OVER THE EDGE AND DOWN THE SIDE OF THE TUB.

**❶** START WITH A CYLINDER THAT LOOKS LIKE A TUB.

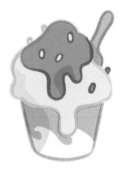

**❸** DRIZZLE A LITTLE SYRUP OVER THE TOP AND SCATTER OVER WITH A FEW SPRINKLES. OH! AND DON'T FORGET THE SPOON!

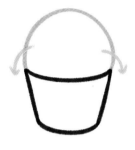

# ICE CREAM CONE

**❶** THE ICE CREAM CONE HAS TWO LARGE SCOOPS OF ICE CREAM.

**❹** YOU CAN EVEN GIVE THE TOP SCOOP A CHEEKY LITTLE ANIMAL HEAD!

**❷** THE ICE CREAM IN THE TOP SCOOP IS DRIPPING ONTO THE ONE BELOW, WHICH IS DRIPPING OVER THE CONE.

**❸** DRAW THE MELTING ICE CREAM AS THICK DROPLETS.

# CARTON OF JUICE

**1** HAVE YOU EVER NOTICED HOW A CARTON OF JUICE LOOKS JUST LIKE A LITTLE HOUSE? TAKE A CLOSER LOOK. IT'S MUCH EASIER TO DRAW NOW TOO. START WITH A CUBE AND ADD A ROOF ON TOP.

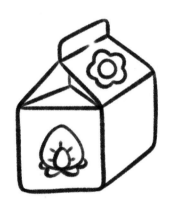

**2** THERE'S A RIDGE RUNNING ALONG THE TOP OF THE ROOF. THERE ARE ALSO A FEW LINES ON THE GABLE WHERE ALL THE FOLDS IN THE PACKAGING COME TOGETHER. SIMPLY DRAW A FLAT TRIANGLE INSIDE THE FIRST AND CONNECT THE TWO BY DRAWING A SHORT LINE AT THE POINT.

**3** NOW ALL THAT'S MISSING IS A COLORFUL PRINT AND A STRAW, OF COURSE!

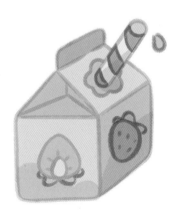

# BOTTLE OF MILK

**1** DRAW A CYLINDER, GETTING NARROWER TOWARDS THE TOP, AND ADD A THIN EDGE FOR THE THREADED LID.

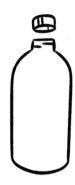

**2** DRAW A LID ON TOP OF THE BOTTLE'S MOUTH AND IT'S DONE.

**3** YOU CAN MAKE THE BOTTLE NARROWER IN THE MIDDLE SO IT'S EASIER TO HOLD.

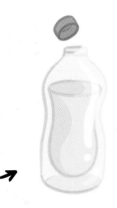

**4** IF THE BOTTLE IS MADE OF GLASS, ADD A GAP ALONG THE OUTLINE WITH NO LIQUID IN IT.

**5** REMEMBER THE HIGHLIGHTS TOO.

# WATER BOTTLE

**1** FOLLOW THE STEPS FOR THE MILK BOTTLE. THIS TIME, HOWEVER, THE SHAPES ARE MORE ANGULAR AND THE GRIP IS MORE DEFINED.

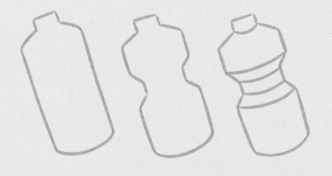

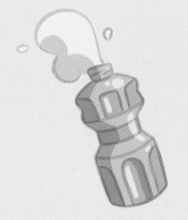

**2** YOU CAN ADD SOME GROOVES IN THE TOP AND BOTTOM OF THE BOTTLE. COLOR THEM A LITTLE DARKER THAN THE OTHER SURFACES TO ADD SOME INTEREST.

# WIND CHIME

THIS JAPANESE CHIME IS MADE FROM GLASS AND IS PAINTED WITH FLOWERS.

**1** DRAW A CIRCLE AND REMOVE THE BOTTOM QUARTER. NOW IT LOOKS LIKE AN UPSIDE-DOWN WINE GLASS.

**3** ADD A STRING WITH A LONG STRIP OF PAPER AT THE END.

**2** DECORATE THE GLASS WITH FLOWERS, AND DON'T FORGET THE HIGHLIGHTS.

# WINKING CAT

**2** ADD TWO SMALL TRIANGLES ON THE TOP OF THE OVAL LIKE CAT EARS.

**1** DRAW TWO OVALS.

**3** MAKE SURE THAT ONE ARM IS POINTING UPWARD AND THE OTHER IS POINTING DOWNWARD. GIVE THE LITTLE GUY A CUTE CAT FACE.

# KOINOBORI

THIS CUTE COLORED FLAG OR WINDSAIL IS SHAPED LIKE A CARP AND CAN BE SEEN FLYING IN FRONT OF JAPANESE HOMES ON MAY 5, CHILDREN'S DAY.

❶ START WITH A CONICAL SHAPE.

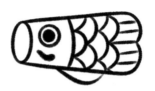

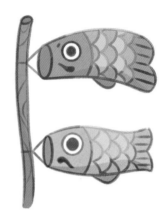

❷ ADD A FIN AT THE BOTTOM AND A TAIL FIN AT THE BACK. ADD THE FISH'S OPEN MOUTH, A LARGE EYE, AND WHISKERS.

❸ THE FISH'S BODY IS COVERED WITH A THICK LAYER OF SCALES ALL THE WAY DOWN TO THE TAIL.

❹ PLACE TWO KOINOBORI ON A WOODEN POLE AND LET THEM FLUTTER IN THE BREEZE.

# DARUMA DOLLS

DARUMAS ARE POPULAR GOOD-LUCK CHARMS. THE OWNER MAKES A WISH AND THEN PAINTS A PUPIL INSIDE THE DOLL'S LEFT EYE. IF THE WISH IS GRANTED, THEY PAINT A PUPIL IN THE RIGHT EYE.

❷ FIRST, DRAW A ROUND SHAPE WITH A WIDE FOOT.

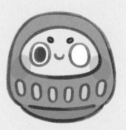

❶ FIRST, DRAW A ROUND SHAPE WITH A WIDE FOOT.

❸ DRAW TWO LARGE EYES AND DECORATE THE FIGURE WITH A YELLOW PATTERN.

# PAPER LANTERN

TRADITIONAL PAPER LANTERNS ARE A MUST
IN ANY JAPAN-INSPIRED DRAWING.

**❶** DRAW THREE RECTANGLES,
A LARGE ONE IN THE MIDDLE
AND TWO SMALL SLIM ONES
ON THE TOP AND BOTTOM.

**❷** ROUND OFF THE MIDDLE
RECTANGLE AS MUCH
AS YOU CAN.

**❸** NOW ADD A STRING
AND ATTACH THE LANTERN
TO A POLE.

# PINWHEEL

**❶** START WITH
AN X.

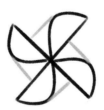

**❸** DRAW A SQUARE
BEHIND. THE CORNERS
SHOULD TOUCH THE
BEND IN EACH S.

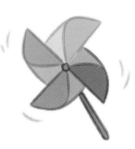

**❷** ADD A LARGE S TO
EACH LINE IN THE X.

**❹** DRAW YOUR
PINWHEEL IN BRIGHT
COLORS AND THAT'S IT!

# IN THE
## Garden

# LEAVES

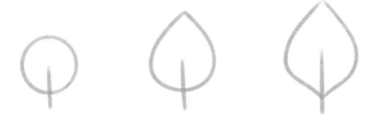

**1** STARTING WITH THESE BASIC SHAPES, YOU CAN DRAW LEAVES OF ALL SHAPES AND SIZES.

**2** ADD POINTS OR DRAW THE OUTLINES IN THE SHAPE OF CLOUDS. YOU CAN ADD FEWER OR MORE DETAILS DEPENDING ON THE SIZE OF THE LEAF.

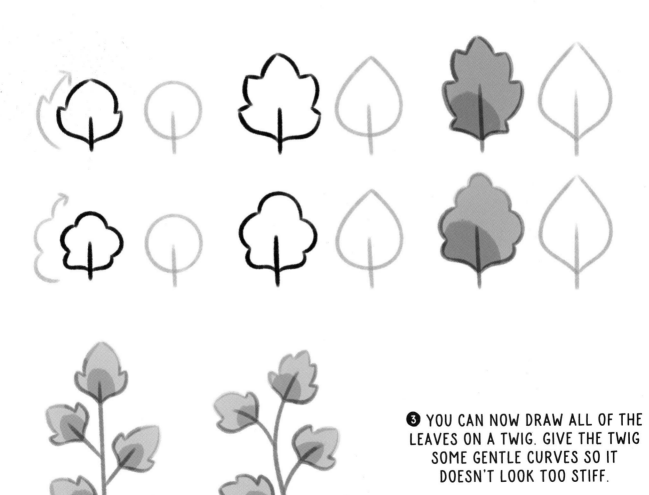

**3** YOU CAN NOW DRAW ALL OF THE LEAVES ON A TWIG. GIVE THE TWIG SOME GENTLE CURVES SO IT DOESN'T LOOK TOO STIFF.

# FLOWERPOT

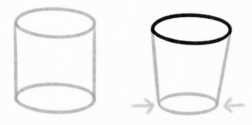

**②** ADD A RIM TO THE POT—YOU CAN NOW PUT A PLANT IN IT.

**①** DRAW A CYLINDER AND MAKE IT NARROWER AT THE BOTTOM THAN AT THE TOP.

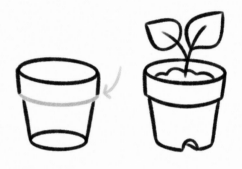

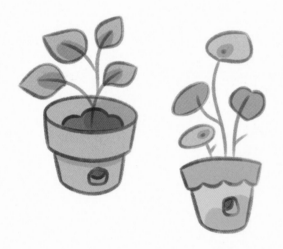

**③** FLOWERPOTS COME IN MANY DIFFERENT SHAPES AND SIZES. EVEN A CUP CAN MAKE A REALLY CUTE POT!

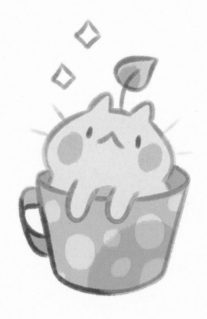

# BUCKET

❶ THE BASIC SHAPE OF THE BUCKET IS THE SAME AS THE FLOWERPOT.

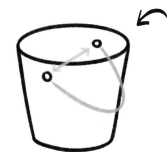

❷ DON'T FORGET THE HANDLE, WHICH IS ATTACHED TO THE HOLES ON EITHER SIDE OF THE BUCKET.

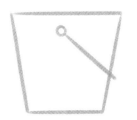

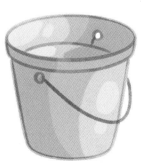

❸ GIVE THE BUCKET A NARROW RIM, AND IT CAN NOW BE FILLED WITH WATER.

# WATERING CAN

❷ THE SPOUT IS ON THE OPPOSITE SIDE NEAR THE BOTTOM AND ENDS IN AN OVAL.

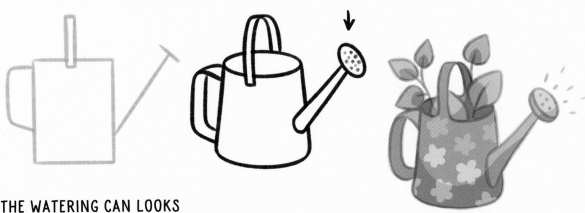

❶ THE WATERING CAN LOOKS LIKE AN UPSIDE-DOWN BUCKET WITH ONE HANDLE ON TOP AND ONE ON THE SIDE.

❸ A WATERING CAN ALSO MAKES AN UNCONVENTIONAL FLOWERPOT!

# FLOWER BUD

**1** START BY DRAWING AN OVAL AT THE TOP OF THE STEM.

**3** ADD A FEW LITTLE CIRCLES TO REPRESENT THE STAMEN.

**2** NOW ADD SOME PETALS, FROM THE UNDERSIDE OF THE BUD UPWARD. THE BUD REMAINS CLOSED.

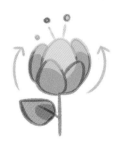

# OPEN FLOWER

**1** STARTING FROM THE BOTTOM OF THE FLOWER, DRAW SEVERAL LARGE OVALS WITH SMALLER OVALS ON TOP.

**2** WHEN DRAWING AN OPEN FLOWER, ARRANGE THE PETALS HORIZONTALLY INSTEAD OF VERTICALLY.

# SIMPLE FLOWER

**1** IN THIS CASE, THE FLOWER IS VIEWED FROM THE TOP. FIRST DRAW A CIRCLE.

**3** I USUALLY START WITH TWO PETALS FACING ONE ANOTHER TO FORM AN X SHAPE. THEN I FILL IN THE GAPS.

**2** ARRANGE THE TEARDROP-SHAPED PETALS AROUND THE CIRCLE.

 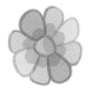

# DETAILED FLOWER

**1** DRAW AN OVAL ON ITS SIDE.

**3** TO MAKE THE FLOWER BIGGER, YOU CAN ADD A FEW MORE PETALS AT THE SIDES.

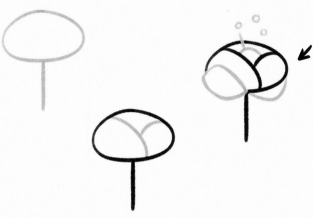

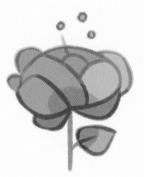

**2** DIVIDE THE OVAL TO CREATE THE FIRST PETALS.

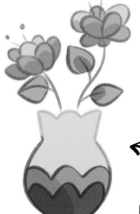

**4** ADD A LEAF TO THE STEM AND A FEW STAMEN.

# VASE OF FLOWERS

**1** HERE WE START WITH A CIRCLE AND A TRIANGLE STANDING ON ITS POINT.

**2** FLATTEN THE BOTTOM OF THE CIRCLE SO THE VASE CAN STAND UPRIGHT.

**4** NOW YOU CAN PUT A PRETTY BOUQUET IN IT.

**3** THE VASE WILL LOOK SWEETER IF YOU DRAW ITS EDGE AS A WAVY LINE.

# SUCCULENTS

- - - - - - - - - -

THE LEAVES OF THIS SUCCULENT ARE RATHER RECTANGULAR AND
NOT AS ROUND AS ON OTHER PLANTS.

❶ START FROM THE
BOTTOM AND DRAW EACH
LEAF INDIVIDUALLY, ONE
AFTER THE OTHER.

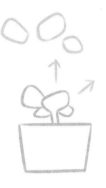

❷ THE LEAVES ARE ARRANGED IN A
SPHERE SHAPE. AT THE TOP AND
BOTTOM, THE LEAVES ARE
SMALLER, WHILE IN THE MIDDLE,
THEY'RE MUCH BIGGER.

❸ ADD A FEW MORE
STEMS WITH JUICY
GREEN LEAVES.

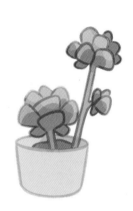

# BAG OF SEEDS

- - - - - - - - - -

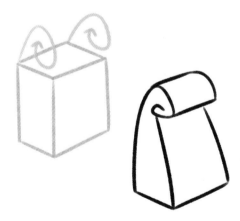

❷ THIS LINE FORMS A SPIRAL
AT THE BACK TO EMPHASIZE
THE ROUNDNESS OF THE
ROLLED-UP PAPER.

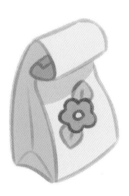

❶ DRAW A RECTANGLE,
MAKE ONE SIDE LONGER, AND
CURVE IT FORWARD OVER THE
TOP OF THE RECTANGLE.

# TROWEL

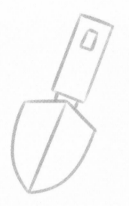

**2** FINISH WITH A DIAMOND SHAPE CONNECTING THE BLADE TO THE HANDLE.

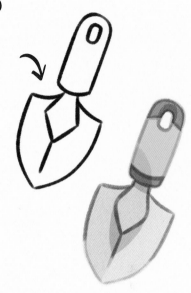

**1** THE HANDLE IS A STURDY RECTANGLE WITH A ROUNDED END. THE TROWEL BLADE CONSISTS OF A TRIANGLE WITH ROUNDED SIDES.

# GARDENING FORK

**1** THE HANDLE IS THE SAME AS FOR THE TROWEL. THE CONNECTION BETWEEN THE HANDLE AND THE TOOL ITSELF, HOWEVER, IS LONGER.

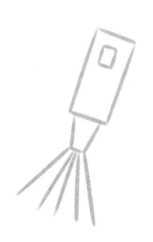

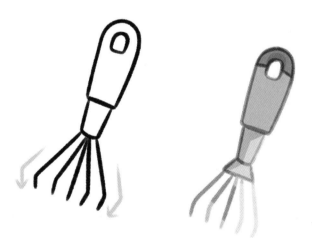

**2** THE PRONGS ARE BENT AT THE END.

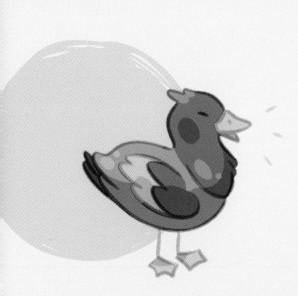

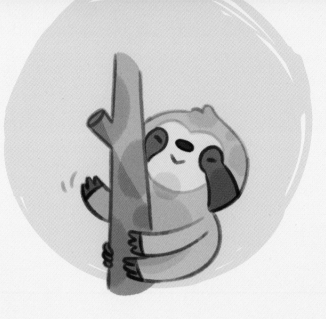

# CUTE Animals

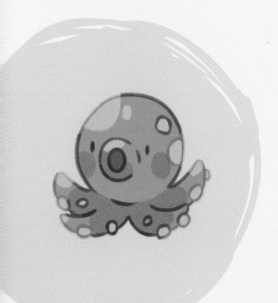

# CAT FACE

**❶** A CAT FACE IS EASIER TO DRAW WITH OVALS THAN CIRCLES. THE CHEEKS LOOK WIDER, GIVING THE CAT A SUPER-SWEET LOOK.

**❷** YOU CAN PUSH THE CHEEKS UP OR DOWN.

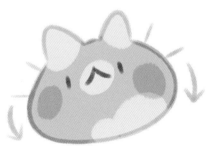

# CAT'S BODY

- - - - - - -

**❶** THE SHAPE OF A CAT'S BODY
IS VERY SIMPLE. ALL YOU NEED
IS AN OVAL WITH FOUR LINES
FOR THE LEGS AND A TAIL.

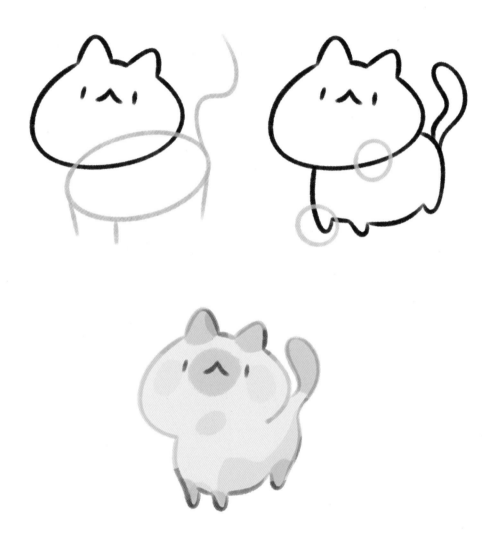

**❷** CONNECT THE HEAD TO THE BODY
WITH COLORING. THE PAWS, EARS, AND
TAIL ARE SHADED IN A DARKER COLOR.

# CUTE CAT IN ACTION

USE THE BASIC SHAPES TO CREATE THE DESIRED POSTURE.
DON'T FORGET ITS CUTE TUMMY AND SWEET LITTLE DERRIERE!

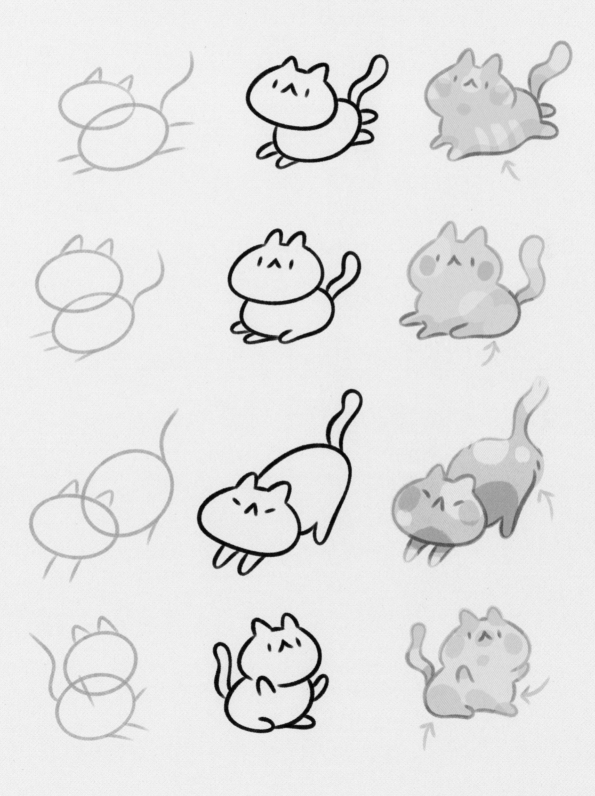

# DOG

– –

DRAWING A DOG ISN'T THAT MUCH DIFFERENT FROM
DRAWING A CAT, APART FROM THE MUZZLE, WHICH IS MUCH LONGER!

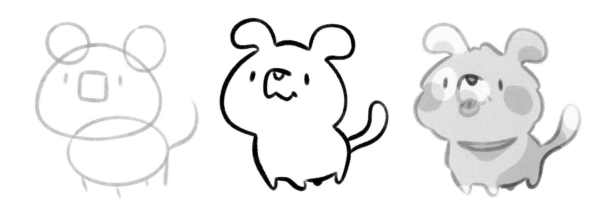

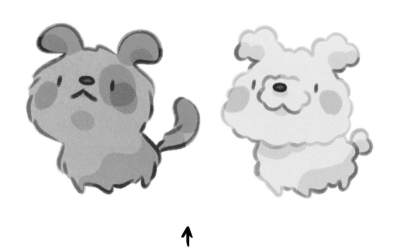

↑

CHANGE THE FUR, EARS, TAIL,
AND MUZZLE AND THE DOG WILL
LOOK COMPLETELY DIFFERENT.

# DOG BREEDS

THERE ARE THREE FEATURES TO FOCUS ON, DEPENDING ON WHICH BREED OF DOG YOU WANT TO DRAW: THE EARS, MUZZLE, AND SHAPE OF THE FACE. THE COLOR OF THE FUR MUST LOOK NATURAL FOR THE BREED TOO.

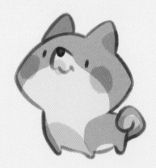

❶ THE SHIBA INU HAS POINTED CHEEKS, POINTED EARS, AND A SMALL MUZZLE. ITS TAIL CURLS UP OVER ITS BACK.

❷ THE FRENCH BULLDOG HAS A VERY WIDE MOUTH WITH THICK, FLOPPY JOWLS, BAT-LIKE EARS, AND A SHORT, CURLED TAIL.

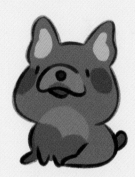

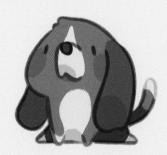

❸ YOU CAN IDENTIFY A BASSET HOUND FROM ITS LONG, DROOPY EARS. DRAW IT WITH A LONG, LARGE MUZZLE AND A THIN TAIL.

❹ THE BEAGLE HAS LONG, FLOPPY EARS AND A LONG TAIL TOO. UNLIKE THE BASSET HOUND, THOUGH, IT HAS A SWEET ROUND MUZZLE. LIKE THE BASSET HOUND, IT IS ALSO A HUNTING DOG.

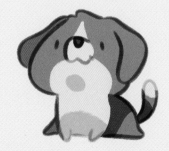

# DOGS IN ACTION

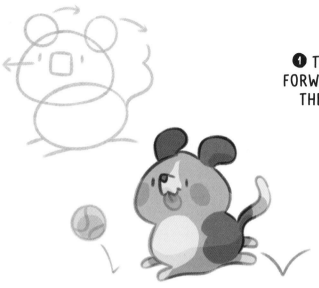

**1** TO DRAW A DOG RUNNING, SHOW IT FACING FORWARD WITH ITS EARS FLAPPING IN THE WIND. THE LEGS ARE OUTSTRETCHED AS IF IT WERE GETTING READY TO JUMP. THEN ADD A LOLLING TONGUE.

**2** IF YOU WANT TO DRAW A DOG WALKING, SHOW THE LEGS ON ONE SIDE FROM THE FRONT AND THOSE ON THE OTHER FROM THE BACK. LET ITS TAIL WAG CHEERFULLY FROM SIDE TO SIDE!

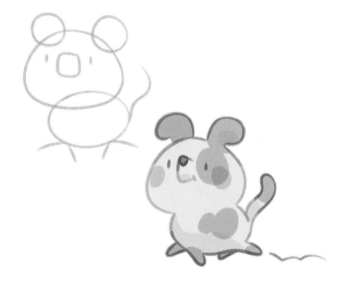

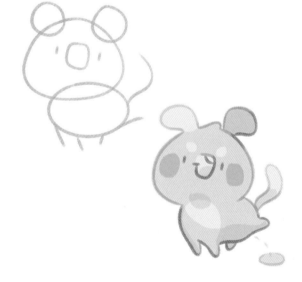

**3** OF COURSE, A DOG ALSO HAS TO DO ITS BUSINESS. DRAW IT LIFTING UP ONE OF ITS LITTLE BACK LEGS AND UNAPOLOGETICALLY DOING WHAT IT NEEDS TO DO, AS IF NOTHING HAD HAPPENED.

# FOX

❶ START WITH THE BODY OF A CAT. ADD POINTY EARS AND CHEEKS AND THEN A LITTLE MUZZLE.

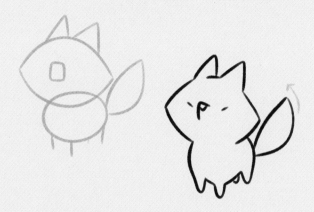

❷ FOXES HAVE A LONG, BUSHY TAIL.

# RABBIT

❷ RABBITS ARE SMALLER. YOU CAN HIGHLIGHT THIS BY MAKING THE HEAD LARGER IN RELATION TO THE BODY.

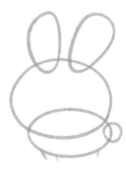

❶ FOR THE BODY, USE THE SAME BASIC SHAPE AS FOR THE CAT OR THE DOG AND ADD TWO LONG EARS.

❸ GIVE IT SOME FLUFFY FUR FOR AN EXTRA-SWEET LOOK!

# BEAR FACES

- - - - - - - -

BEARS HAVE THE SAME FEATURES AS DOGS. THE ONLY DIFFERENCE IS THAT THEY HAVE LARGER MUZZLES AND THEIR EARS ARE ROUND. WITH A FEW SMALL CHANGES, YOU CAN DRAW LOTS OF DIFFERENT BEAR SPECIES TOO.

**❶** THE PANDA HAS ROUND, STAND-UP EARS AND BLACK FUR AROUND ITS EYES.

**❷** GRIZZLY BEARS ARE THE EASIEST TO DRAW. GIVE THEM TWO LARGE ROUND EARS AND THEY'RE DONE!

**❸** A KOALA'S EARS ARE OVERSIZED AND FLUFFY AND STAND OUT TO THE SIDES. THEY ALSO HAVE A LONG BROWN MUZZLE. THEY'RE NOT BEARS, THOUGH: THEY'RE MARSUPIALS.

# BEAR BODY

- - - - - - -

UNLIKE A PUPPY, GRIZZLY AND POLAR BEAR CUBS DON'T STAY CLUMSY AND
SMALL. NO, THEY CAN GET REALLY, REALLY MASSIVE. I MAKE THEM LOOK
SWEET REGARDLESS. WHEN BEARS GROW, THEIR BODIES GET LARGER AND
LARGER, SO MUCH SO THAT THEIR HEADS LOOK TINY IN COMPARISON.

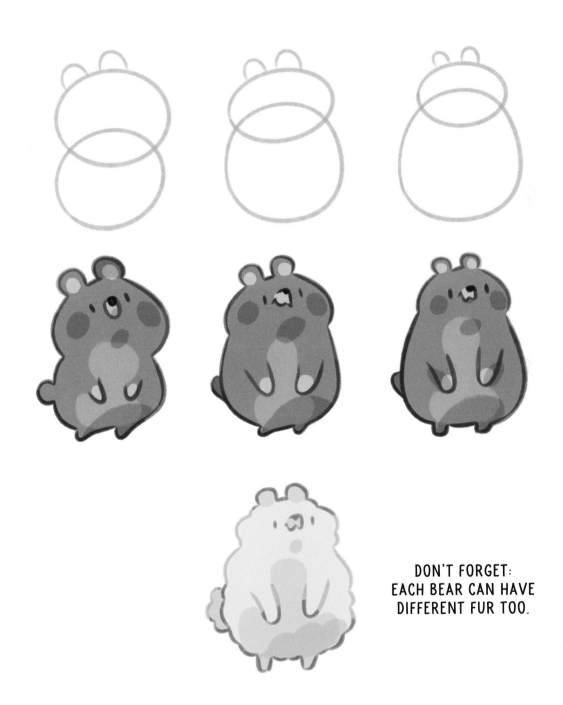

DON'T FORGET:
EACH BEAR CAN HAVE
DIFFERENT FUR TOO.

# RACCOON

**1** YOU CAN DRAW A RACCOON LIKE A SMALL PANDA.

**3** YOU CAN CHOOSE ANY COMBINATION OF COLORS YOU LIKE FOR THE FUR. PAY ATTENTION TO THE UNIQUE MARKINGS ON THE FUR AROUND THE EYES AND ON THE TAIL.

**2** ITS LITTLE FACE IS POINTED AT THE SIDES WITH BIG, DARK RINGS AROUND THE EYES. IT ALSO HAS A LONG, BUSHY TAIL.

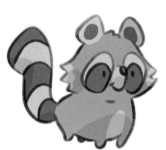

# SQUIRREL

**2** SQUIRRELS HAVE A SLIM BODY. AN IMPORTANT FEATURE IS THE LONG, BUSHY TAIL, WHICH CURLS AT THE END.

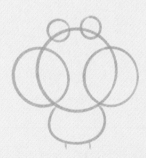

**1** DRAW A CIRCLE FOR THE HEAD AND TWO SMALL CIRCLES ON TOP FOR THE EARS. TWO LARGE CIRCLES FORM THE SQUIRREL'S CHUBBY CHEEKS

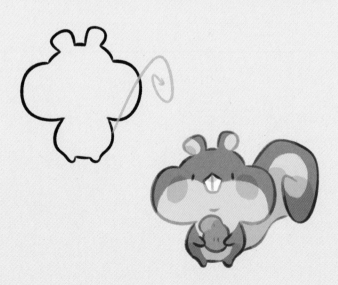

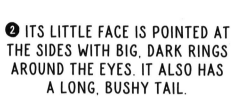

# SLOTH

----

① SLOTHS SPEND ALL OF THEIR TIME HANGING IN A TREE. SO FIRST OF ALL, GIVE THE SLOTH A THICK TREE TRUNK TO HOLD ON TO. THEN DRAW A LARGE HEAD AND A SMALL BODY. BECAUSE THE SLOTH'S LIMBS ARE SO LONG, IT DOESN'T NEED A LARGE BODY.

② THE ARMS AND LEGS HUG THE TREE TRUNK. THE HANDS AND FEET HAVE THREE LONG CLAWS WHICH MAKE CLIMBING EASIER.

③ THE FACE IS LIGHTER THAN THE BODY. ADD THE DARK, WIDE STRIPES RUNNING FROM THE EYES AND OUT ALONG THE SIDES OF THE FACE.

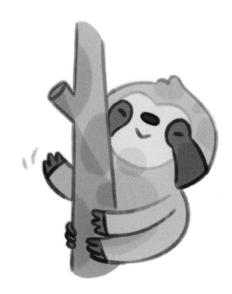

# CHICKEN

**2** ADD A SMALL BEAK AND A CIRCLE FOR THE WING.

**3** LASTLY, GIVE YOUR SWEET CHICKEN ITS TRADEMARK COMB AND WATTLE.

**1** DRAW A LARGE HORIZONTAL OVAL AND ADD A SMALLER VERTICAL ONE ON ONE SIDE FOR THE HEAD.

**4** COMPLETE THE SCENE WITH A LITTLE BIT OF STRAW AND A FEW EGGS.

# PIGEON

**2** ITS WINGS ARE THE SHAPE OF A TEARDROP.

**1** YOU CAN USE THE SAME SHAPES YOU USED FOR THE CHICKEN; HOWEVER, THIS TIME, THE HEAD IS SMALLER AND THE BODY IS LONGER AT THE BACK.

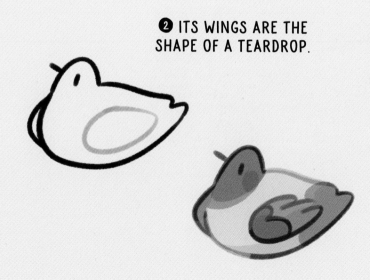

# DUCK

❶ THE BASIC SHAPE IS SIMILAR TO THE OTHER BIRDS.

❸ DUCK FEATHERS HAVE WONDERFUL SHIMMERING COLORS.

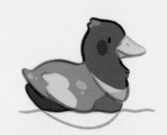

❷ DRAW THE HEAD WITH A LARGE, WIDE BEAK AND LOTS OF TAIL FEATHERS.

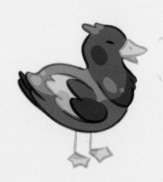

❹ MAKE SURE TO ADD PLENTY OF COLOR TRANSITIONS ON THE WINGS AND TAIL.

# PLATYPUS

PLATYPUSES ARE TRULY BIZARRE CREATURES, BUT THEY'RE JUST SO FUNNY.

❷ PLATYPUSES HAVE A WIDE DUCKBILL AND WEBBED TOES.

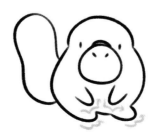

❶ FIRST DRAW THE BODY AND A SMALL HEAD.

❸ THEIR LONG TAIL IS FLAT AND ROUNDED AT THE END.

# LADYBUG

LADYBUGS ARE REALLY SWEET. THEY LOOK ESPECIALLY GOOD
WHEN DRAWN WITH FLOWERS OR OTHER PLANTS.

**②** DRAW A LINE DOWN
THE MIDDLE OF THE BACK
TO SHOW THE WINGS.

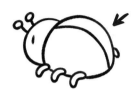

**①** DRAW A ROUND BODY. GIVE THE
LITTLE CREATURE TWO ANTENNAE AND
THREE SHORT LEGS ON EACH SIDE
OF THE BODY.

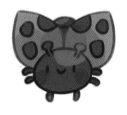

**③** THE DOTS ON THE BACK ARE
ARRANGED SYMMETRICALLY.

# BUMBLEBEE

BUMBLEBEES ARE ROUND AND REALLY FLUFFY.

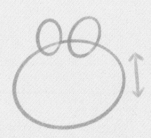

**②** ADD THE LITTLE LEGS
AND THE ANTENNAE.

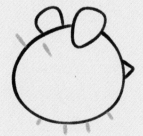

**①** DRAW A CIRCLE AND ADD
TWO SMALL WINGS ON THE TOP.

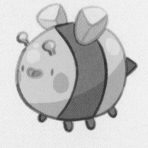

**③** DON'T FORGET TO ADD THE
STRIPES ON THE BODY! MAKE
THEM AS WIDE AS POSSIBLE.

# SNAIL

**❶** FIRST DRAW THE SNAIL'S BODY ON ITS OWN, WITH ANTENNAE ON THE HEAD.

**❸** FINISH BY ADDING ITS FAVORITE MEAL IN ITS MOUTH: A LETTUCE LEAF!

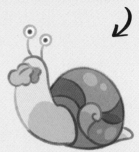

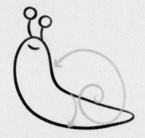

**❷** THE BASIC SHAPE FOR THE SNAIL'S SHELL IS A SPIRAL. THE SPIRAL IS NARROW AT THE CENTER OF THE SHELL AND GETS WIDER AND WIDER TOWARDS THE BOTTOM. DON'T FORGET THE ROUND EYES ON TOP OF THE ANTENNAE!

# TURTLE

**❷** AT THE TRANSITION BETWEEN THE NECK AND THE SHELL, YOU CAN DRAW A LITTLE ROLL OF SKIN. DRAW THE FLIPPERS USING SEMICIRCLES AND THEN ADD ITS LITTLE TAIL.

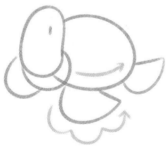

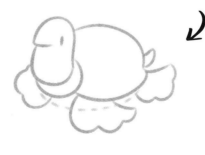

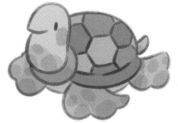

**❶** START WITH A LARGE, ROUND SHELL AND ADD AN OVAL ON ONE SIDE FOR THE HEAD.

**❸** THE SHELL IS ALSO ROUND UNDERNEATH.

# OCTOPUS

**❶** FIRST DRAW THREE CIRCLES ONE INSIDE OF THE OTHER. ADD THE TENTACLES BELOW THE LARGE CIRCLE AND HAVE THEM WRIGGLING IN DIFFERENT DIRECTIONS.

**❷** THE TENTACLES START OFF THICK AND TAPER INTO POINTS AT THE END. ADD AS MANY SUCKERS AS YOU LIKE, IN ALL DIFFERENT SIZES.

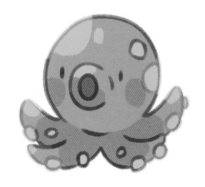

**❸** DON'T GET HUNG UP ON HOW MANY TENTACLES AN OCTOPUS ACTUALLY HAS IN REAL LIFE. I KEEP IT TO FOUR OR FIVE—IT LOOKS SWEETER THAT WAY. DON'T FORGET TO ADD THE OCTOPUS' EYES AT THE END.

# TADPOLE

**❷** THE S-SHAPED TAIL IS AS LONG AS THE HEAD.

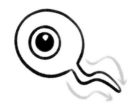

**❶** DRAW A CIRCLE FOR THE HEAD AND ADD A SECOND SMALLER ONE FOR THE EYE.

**❸** ADD THE FINS AROUND THE TAIL IN A LIGHTER COLOR, AS THEY'RE SLIGHTLY TRANSPARENT.

# FISH

**❶** START WITH AN OVAL, ADD A LARGE ROUND EYE, A LARGE ARCH FOR THE GILLS, AND THE TAIL FIN AT ONE END.

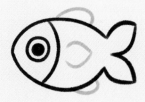

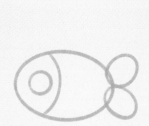

**❷** YOU CAN ADD MORE FINS TOO. TO MAKE THE FINS LOOK SWEETER, YOU CAN GIVE THE EDGES A WAVY OUTLINE LIKE A LEAF.

# GOLDFISH BOWL

THE LITTLE FISH NEEDS TO GET BACK IN THE WATER—AND FAST. LET'S GIVE IT A CUTE GOLDFISH BOWL!

**❶** DRAW A LARGE SPHERE WITH TWO SMALLER OVALS ON THE TOP AND BOTTOM.

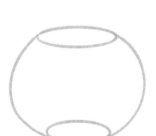

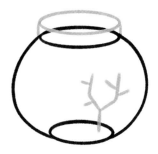

**❷** PLACE A SMALL CORAL BRANCH INSIDE AND A HIGH RIM AROUND THE MOUTH OF THE BOWL.

**❸** NOW GIVE THE RIM A WAVY OUTLINE AND FILL THE BOWL WITH WATER.

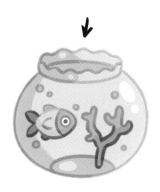

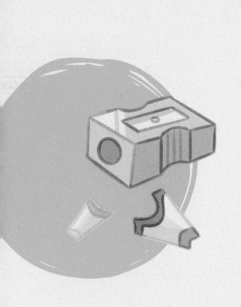

# IN
## School

# PENCIL

❶ START WITH A LONG, THIN CYLINDER WITH A POINT AT ONE END.

❸ TOP WITH THE TYPICAL ERASER.

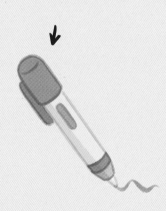

❷ THE CYLINDER IS DIVIDED INTO VERTICAL STRIPES SO IT LOOKS LIKE AN OLD-FASHIONED SCHOOL PENCIL.

# BALLPOINT PEN

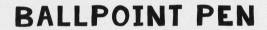

❶ START WITH THE BASIC PENCIL SHAPE.

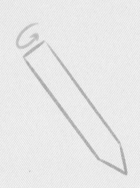

❸ ADD A CAP WITH A CLIP TO THE TOP END.

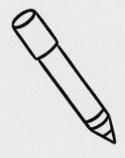

❷ ADD A ROUND PEN TIP TO THE POINTED END.

# MARKER

**❶ ONCE AGAIN, START WITH THE BASIC PENCIL SHAPE.**

**❷ NOW GIVE IT A SHORTER CAP WITH NO CLIP.**

**❸ MARKERS HAVE A FIBER TIP, WHICH FLEXES WHEN THE PEN IS PRESSED AGAINST THE PAPER.**

# ERASER

**❶ YOU CAN DRAW AN ERASER AS A PERFECT CUBOID.**

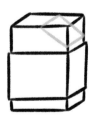

**❷ IT WILL LOOK MORE REALISTIC IF ONE END LOOKS LIKE IT'S BEEN USED A BIT.**

**❸ GIVE IT A LITTLE COLORED SLEEVE.**

# SCISSORS

SCISSORS LOOK QUITE COMPLICATED. IF YOU DRAW THEM STEP BY STEP, THOUGH, THEY'RE NOT ALL THAT DIFFICULT.

❷ ADD THE BLADES TO THE OUTSIDE OF THE OTHER END OF THE X.

❶ THE IMPORTANT PART IS A LARGE X. THE ARMS OF THE X ARE SLIGHTLY LONGER AT THE HANDLE END. FIRST, DRAW A SEMICIRCLE ON THE OUTSIDE OF THE X.

❸ ONE BLADE PARTIALLY OVERLAPS THE OTHER. SO THE SCISSORS ARE MORE COMFORTABLE TO USE, MAKE THE HANDLES MORE OVAL AND ROUND OFF THE POINTS.

# SHARPENER

❷ THE SHARPENER HAS RECESSED GRIPS ON EACH SIDE.

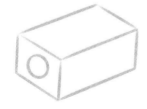

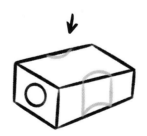

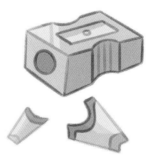

❶ START WITH A CUBOID AND MAKE IT SLIGHTLY NARROWER AT THE BACK THAN AT THE FRONT. DRAW A CIRCLE FOR THE OPENING AT THE FRONT.

❸ FINISH BY ADDING THE BLADE TO THE TOP OF THE CUBOID.

# WASHI TAPE

**①** A ROLL OF WASHI TAPE LOOKS LIKE A DOUGHNUT WITH PRECISE EDGES.

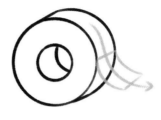

**②** DRAW A CURVED RECTANGLE ON ONE SIDE TO SHOW A PIECE OF WASHI TAPE STICKING OUT FROM THE ROLL.

**③** THE CUT EDGE HAS A ZIGZAG PATTERN.

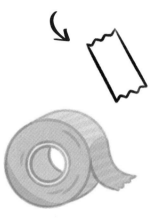

# PENCIL CASE

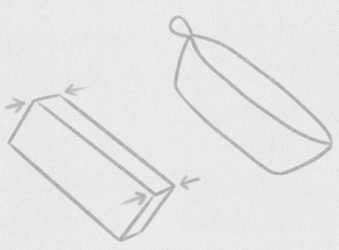

**②** ADD A ZIPPER ALONG THE TOP EDGE AND PUT YOUR PENCILS INSIDE.

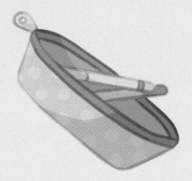

**①** DRAW A CUBOID WHICH IS WIDE AT THE BOTTOM AND NARROW AT THE TOP CORNERS.

# SATCHEL

**1** THE SATCHEL IS DRAWN AS A CUBOID AND IS CLOSED WITH A FLAP.

**3** NOW ADD A SPACIOUS FRONT POCKET AND A HANDLE ON THE TOP.

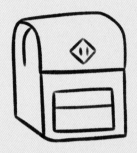

**2** A ZIPPER ON THE SIDE AND TWO FRONT FASTENERS MAKE SURE THAT NOTHING FALLS OUT.

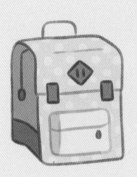

# BACKPACK

**2** A ZIPPER RUNS ACROSS THE TOP. THE FRONT POCKET IS NARROW AT THE BOTTOM AND WIDER AT THE TOP.

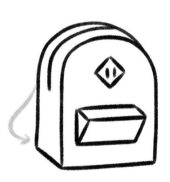

**1** START WITH A CUBOID AND MAKE THE TOP EDGES ROUND.

**3** NOW ADD THE STRAP AND THE HANDLE.

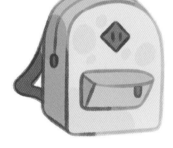

# BOOK

❶ THE BASIC SHAPE IS A CUBOID.

❷ THE SHORT SIDES ARE DRAWN AS CURVED LINES. THE TOPS OF THE ARCHES ALL POINT THE SAME DIRECTION.

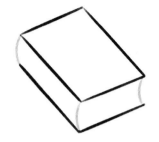

❸ MAKE THE COVER OF THE BOOK THICKER. NOW YOU CAN DECORATE THE BACK OF THE BOOK, ITS COVER, AND THE CORNERS AS YOU LIKE.

# SPIRAL NOTEBOOK

❶ DRAW A CUBOID AND ADD A THICK PIECE OF CARDBOARD TO THE FRONT AND BACK.

❷ THERE IS A LARGE SPIRAL RUNNING DOWN ONE OF THE VERTICAL SIDES. TO MAKE THINGS EASIER, YOU CAN DRAW CIRCLES THAT ARE ALL THE SAME SIZE.

# OPEN BOOK

**1** TO DRAW AN OPEN BOOK, THE CUBOID IS TWICE AS WIDE AND HALF AS TALL AS A CLOSED BOOK.

**2** STARTING FROM THE CENTER LINE, DRAW FOUR CURVED LINES FOR THE OPEN PAGES.

**3** FOR A SINGLE OPEN PAGE, ADD ANOTHER CURVED RECTANGLE FROM THE CENTER OF THE BOOK.

**4** NOW WE JUST NEED TO ADD IN THE DETAILS: PICTURES, TEXT, AND A THICK COVER.

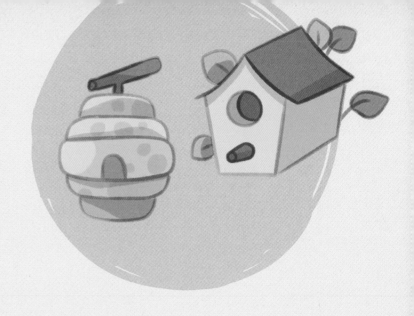

# SWEET DRAWING
# THROUGH THE
# Seasons

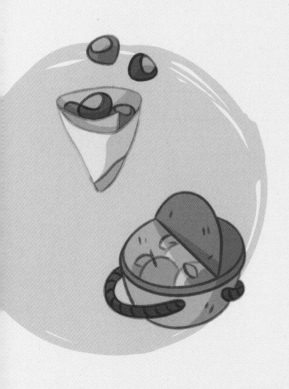
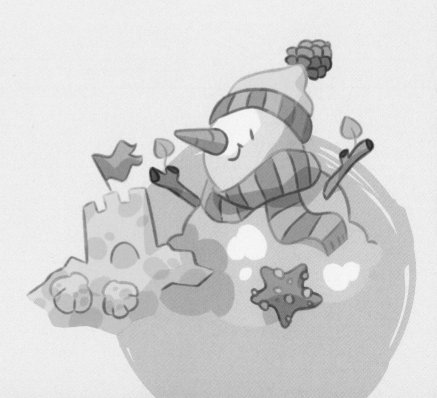

# SNOWMAN

------

❶ START WITH TWO LARGE SNOWBALLS. THE LOWER SNOWBALL HAS A FLAT BOTTOM. THAT WAY, IT WILL STAND STABLE.

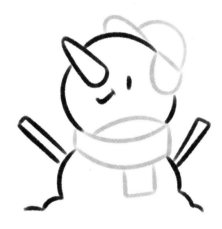

❷ OUR SNOWMAN HAS A CARROT FOR A NOSE AND TWO TWIGS FOR ARMS.

❸ NOW ALL HE NEEDS IS A HAT OR A CAP AND A SCARF, OF COURSE—IT'S FREEZING COLD OUT THERE, AFTER ALL!

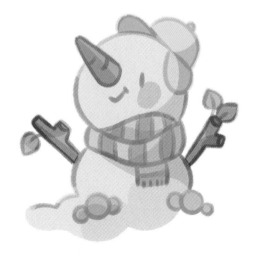

# YULE LOG

THIS CAKE LOOKS LIKE A LOG AND IS A CHRISTMAS ESSENTIAL
IN MANY COUNTRIES, SUCH AS FRANCE.

**❶** DRAW A LONG, THICK
CYLINDER WITH A SPIRAL ON
THE FRONT SLICED EDGE.

**❸** THE OUTSIDE OF THE CAKE IS
COLORED DARK CHOCOLATE
BROWN. THE BISCUIT ROLL CAN
BE FILLED WITH STRAWBERRY
JAM, MERINGUE, OR CHOCOLATE.

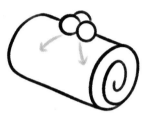

**❷** DECORATE THE CAKE
WITH BERRIES AND
HOLLY LEAVES.

# GINGERBREAD MAN

**❷** THE SHINY ICING IS APPLIED
SLIGHTLY AWAY FROM THE EDGE.

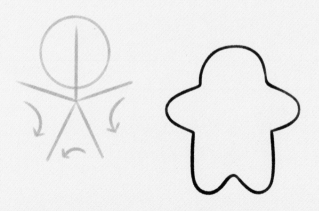

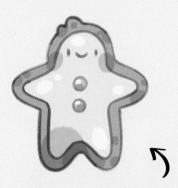

**❶** START WITH A STAR-SHAPED BODY.
THE HEAD IS LARGER THAN
THE ARMS AND LEGS.

**❸** FINISH WITH A SMILEY FACE
AND BUTTONS DOWN THE FRONT
OF THE BODY. DON'T FORGET
THE HIGHLIGHTS!

# SIX-SIDED SNOWFLAKE

❶ DRAW A HEXAGON AND LENGTHEN THE SIDES SLIGHTLY SO THEY EXTEND BEYOND THE POINTS WHERE THE TWO SIDES MEET.

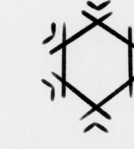

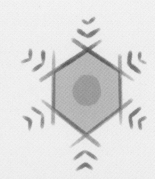

❸ CONTINUE THE V PATTERN OUTWARD WITH TWO MORE ROWS OF VS.

❷ THIS CREATES A SMALL V.

# STAR-SHAPED SNOWFLAKE

❷ ADD A LITTLE INWARD-POINTING V ON EACH SIDE TO FORM A STAR.

❶ DRAW A HEXAGON.

❸ DRAW A LINE WITH TWO SMALL V SHAPES IN THE CENTER OF EVERY SPACE BETWEEN THE LARGER VS.

# SUNFLOWER

**❷** ADD AN INITIAL ROW OF SMALLER PETALS ALONG THE EDGE OF THE INSIDE CIRCLE.

**❶** START WITH ONE LARGE AND ONE SMALL CIRCLE.

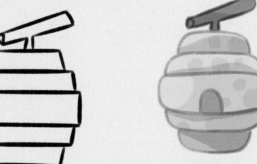

**❹** END BY ADDING TWO LARGE GREEN LEAVES TO THE STEM.

**❸** FILL IN THE GAPS WITH LARGER PETALS.

# BEEHIVE

**❷** SMOOTH OUT THE EDGES, BUT MAKE SURE THE OUTLINE RETAINS ITS OVAL SHAPE.

**❶** DRAW AN OVAL AND DIVIDE IT HORIZONTALLY INTO FIVE STRAIGHT STRIPES.

**❸** ADD A SMALL ENTRANCE HOLE ON THE FRONT AND HANG THE HIVE FROM A BRANCH.

# SANDCASTLE

- - - -

**1** THE BASIC SHAPE LOOKS LIKE AN UPSIDE-DOWN BUCKET. DIVIDE THE TOP INTO FIVE SEGMENTS.

**3** NOW YOU CAN RAISE THE FLAG!

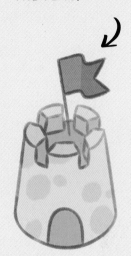

**2** PLACE A CUBE AT THE END OF EACH DIVIDING LINE TO FORM THE TURRETS.

# CRAB

- - - - -

**2** ADD THREE LEGS AND A LARGE CLAW ON EACH SIDE.

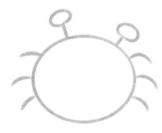

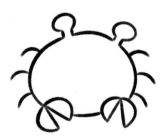

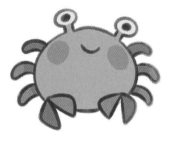

**1** DRAW A LARGE CIRCLE AND ADD TWO ANTENNAE ON TOP.

**3** GIVE THE FUNNY LITTLE GUY EYES AND A CUTE FACE.

# SEASHELL

**❶** DRAW A CIRCLE WITH A THIN RECTANGLE ALONG ONE SIDE.

**❷** DIVIDE THE SHELL INTO FIVE SEGMENTS, EACH ENDING IN A LITTLE ARCH.

# STARFISH

**❷** NOW FILL THE STAR WITH CIRCLES OF VARIOUS SIZES TO HIGHLIGHT THE ROUGH SURFACE.

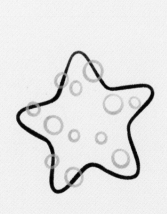

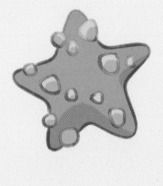

**❶** DRAW A FIVE-POINTED STAR AND ROUND OFF ALL THE POINTS AND INDENTATIONS.

# ACORN

**1** DRAW A CIRCLE AND A WIDE OVAL ON TOP.

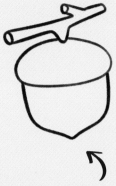

**3** ADD A FEW SCALES TO THE CUP AND HANG THE ACORN FROM A BRANCH.

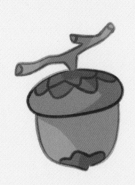

**2** THE CIRCLE HAS A LITTLE POINT ON THE BOTTOM AND A CUP ON THE TOP.

# PINE CONE

**2** TO MAKE THE CONE LOOK MORE REALISTIC, THE SCALES SHOULD ALL LOOK DIFFERENT AND BE SLIGHTLY ANGULAR IN SHAPE.

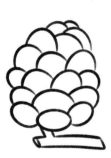

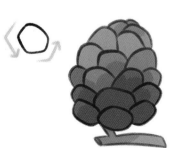

**1** HERE WE BEGIN WITH AN OVAL, COVERING IT WITH INDIVIDUAL SCALES STARTING FROM THE BOTTOM.

# CHESTNUT

- - - - -

CHESTNUTS LOOK LIKE ACORNS, ONLY THEY DON'T HAVE A CAP AND ARE SLIGHTLY WIDER AT THE TOP. THEY ALSO HAVE A VERY POINTY BOTTOM.

**❶ FIRST DRAW AN OVAL WITH A TRIANGLE ON THE BOTTOM.**

**❷ ROUND OFF ALL THE EDGES AND COLOR USING THREE DIFFERENT SHADES OF BROWN.**

# BAG OF CHESTNUTS

- - - - - - - - -

**❶ DRAW A CONE WITH A POINTED BOTTOM.**

**❸ NOW IT CAN BE FILLED WITH LOTS OF HOT, TASTY CHESTNUTS!**

**❷ DIVIDE THE SHAPE SO YOU CAN SEE THAT THE BAG IS MADE OUT OF A SHEET OF PAPER.**

# BIRDHOUSE

**❷ IF YOU WANT TO MAKE IT LOOK NICER, GIVE IT A SLOPING ROOF AND MAKE THE HOUSE A LITTLE NARROWER.**

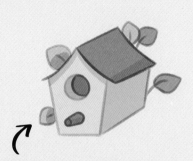

**❶ START WITH A SIMPLE LITTLE HOUSE WITH A POINTED ROOF. REPLACE THE USUAL DOOR WITH A ROUND HOLE.**

**❸ FINISH BY DRAWING A BRANCH BELOW THE ENTRANCE HOLE AND A FEW LEAVES.**

# PICNIC BASKET

A PICNIC IS PROBABLY THE MOST FUN IN SPRING. BUT FIRST YOU NEED A CUTE BASKET.

**❷ OPEN ONE OF THEM SO YOU CAN SEE INSIDE AND ADD A HANDLE ON EACH SIDE.**

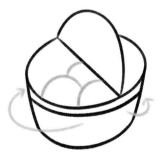

**❶ DRAW A WIDE CYLINDER AND DIVIDE THE TOP THROUGH THE MIDDLE TO CREATE A LID WITH TWO FLAPS.**

**❸ NOW IT CAN BE FILLED WITH TASTY FOOD OR JUICY FRUIT!**

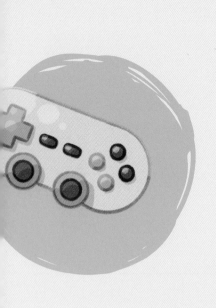

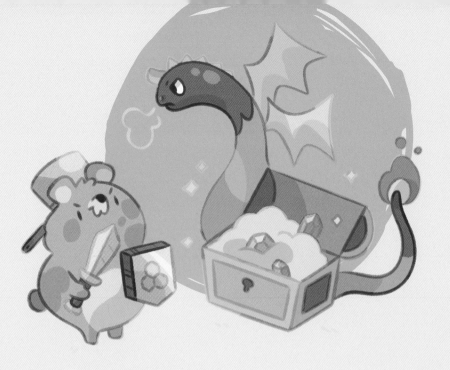

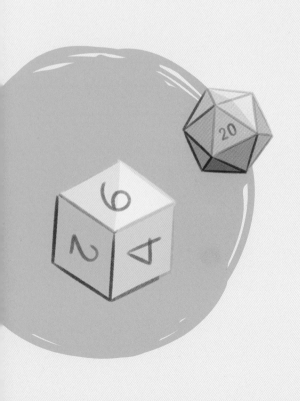

Playtime

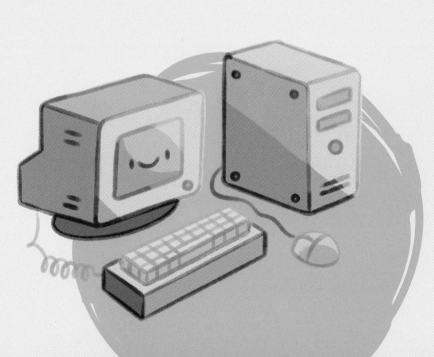

# TREASURE CHEST

**❶** THE BASIC SHAPE IS A LARGE CUBOID WITH NO TOP.

**❷** VAULT THE LID AND DECORATE THE EDGES WITH METAL FITTINGS. ADD A LOCK AND FILL THE CHEST WITH SHINY GOLD COINS AND GLITTERING GEMS.

**❸** TO MAKE A CLOSED CHEST, DRAW A HALF CYLINDER ON TOP OF A CUBOID.

# GEMSTONES

THESE GEMSTONES HAVE A HEXAGONAL CUT. HOWEVER, YOU CAN ALSO MAKE THEM OTHER SHAPES.

**❷** WHEN COLORING, MAKE SOME SURFACES DARKER THAN THE OTHERS SO THAT YOUR JEWELS LOOK SHINIER.

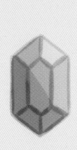

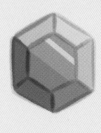

**❶** THE SMALLER SHAPE ON THE INSIDE NEEDS TO MATCH THE OUTLINE OF THE OUTSIDE SHAPE, AS WELL AS THE CORNERS.

# THE HERO'S SWORD & SHIELD

**1** START WITH A LONG RECTANGLE WITH A POINTED END. THIS END SHOULD BE WIDER THAN THE GRIP.

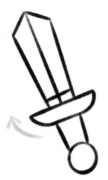

**3** THE GRIP CAN BE DECORATED WITH A GEMSTONE OR WRAPPED IN A STRIP OF LEATHER.

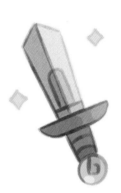

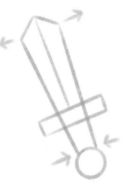

**2** THE GRIP ENDS IN A SPHERE (THE POMMEL) AND THE GUARD IS SLIGHTLY ROUNDED.

**1** FOR THE SHIELD, DRAW A SQUARE WITH A POINTED BOTTOM

**2** GIVE THE SHIELD SOME VOLUME.

**3** DECORATE IT WITH A SIMPLE YET SWEET EMBLEM TO IDENTIFY ITS BEARER.

# DICE

MOST BOARD GAMES NEED DICE. TRADITIONAL DICE HAVE 6 SIDES; HOWEVER,
THERE ARE DICE WITH 4, 8, 10, 12, OR EVEN 20 SIDES!

❶ FOR A SIX-SIDED DIE,
DRAW A CUBE.

❷ DRAW A NUMBER ON EACH FACE.
MAKE SURE THAT THE OPPOSITE FACES
ADD UP TO A TOTAL OF SEVEN.

❹ ADD THE FACES OF THE DIE
BY DRAWING A LINE FROM
CORNER TO CORNER. THIS
CREATES LOTS OF TRIANGULAR
SURFACES.

❸ TO DRAW A 20-SIDED DIE,
START WITH A CUBE WITH A
TRIANGLE IN THE MIDDLE.

# GAME PAD

GAME CONTROLLERS COME IN ALL SHAPES AND SIZES. I LIKE THE OLD STYLE
BEST THOUGH—THEY WERE STREAMLINED AND LOOKED CUTE.

  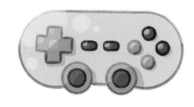

❶ START WITH TWO CIRCLES AND
CONNECT THEM WITH TWO LINES TO
FORM AN OBLONG. THE TWO
BUTTONS AT THE BOTTOM
ARE THE THUMBSTICKS.

❷ DRAW A CROSS ON EACH SIDE, ONE
FOR THE CONTROL PAD AND THE
OTHER FOR THE BUTTONS.

# GAME CONSOLE

YOU CAN USE THE CONTROLLER DESIGN AS A STARTING POINT AND ADD
A SCREEN TO CREATE YOUR OWN DESIGN FOR A PORTABLE CONSOLE.
THIS IS A VERY SIMPLE MODEL.

❶ FIRST DRAW A CUBOID.

❷ ADD THE BUTTONS TO THE BOTTOM HALF
AND PLACE A LARGE SCREEN IN THE TOP
HALF. DON'T FORGET TO ROUND OFF
ALL THE EDGES!

108

# COMPUTER

**3** THIS MODEL REALLY IS OLD, SO MAKE SURE YOU REMEMBER THE CABLE ON THE BACK!

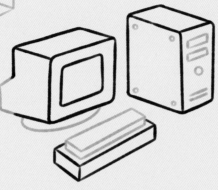

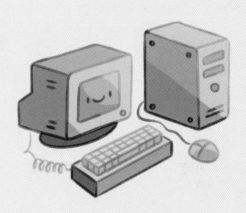

**1** DRAW ALL THE COMPONENTS AS CUBES AND CUBOIDS TO MAKE THEM MORE SIMPLE.

**2** THEN ADD THE DETAILS AND ROUND OFF THE CORNERS.

# CAT-EAR HEADPHONES

**2** DRAW THE CUSHIONS FOR THE PADS SO THE HEADPHONES ARE MORE COMFORTABLE TO WEAR— AND THEN THE SWEET LITTLE CAT EARS, OF COURSE!

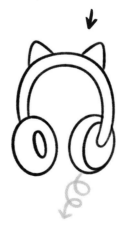

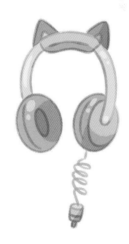

**1** DRAW THE ARCH FOR THE HEAD BAND AND ADD THE EAR PADS ON EACH SIDE.

**3** DON'T FORGET THE LONG SPIRAL CORD WITH THE PLUG AT THE END.

# ACKNOWLEDGMENTS

Just a few years ago, it would never have crossed my mind to write a book like this. To me, drawing was nothing more than a hobby and publishing a book about it was something I could only dream of.

At some point, just for fun, I started posting tutorials online. They soon became very popular with the little community that formed around them. Without the continuous support of my followers, I wouldn't have reached this point in my career as an artist. Thank you from the bottom of my heart. Your belief in my work has given me courage and has shown me that drawing can be much more than just a hobby—I really can make it my job.

I'd also like to thank my family for their constant support on my journey to becoming an illustrator. Special thanks go to my mum, who taught me just how special kawaii faces are. Albert, thank you for always believing in me, sometimes more than I believed in myself. Thanks also to Saskia, who is so kind and has shown that language doesn't have to be a barrier. Thanks also to everyone who is discovering my work through this book. Thank you!

# ABOUT THE AUTHOR

Olga Ortiz, also known as Olguioo, currently lives in Lleida, a small city in Catalonia (Spain), where she works as an illustrator and graphic designer. Olga originally trained as an architect; however graphic design has always been her greatest passion. This passion inspired her to create a small community on social media for sharing her drawings and tutorials. Finally, she decided to turn her hobby into a career. Most of all, Olga likes drawing sweet animals, cute plants, food, and everyday objects that make her happy. Alongside her drawings, she also hopes to share this feeling with others.

**Quarto.com • WalterFoster.com**

 © Edition Michael Fischer GmbH, 2022

www.emf-verlag.de

This translation of SWEET ZEICHNEN first published in Germany by Edition Michael Fischer GmbH in 2022 is published by arrangement with Silke Bruenink Agency, Munich, Germany.

Published in 2023 by Walter Foster Publishing, an imprint of The Quarto Group, 100 Cummings Center, Suite 265D, Beverly, MA 01915, USA. T (978) 282-9590 F (978) 283-2742

Walter Foster Publishing titles are also available at discount for retail, wholesale, promotional, and bulk purchase. For details, contact the Special Sales Manager by email at specialsales@quarto.com or by mail at The Quarto Group, Attn: Special Sales Manager, 100 Cummings Center, Suite 265D, Beverly, MA 01915, USA.

27 26 25 24 23    1 2 3 4 5

ISBN: 978-0-7603-8533-3

Text and Illustrations: Olga Ortiz
Page Layout: Sporto
Translation: Jessica West

Printed in China